NICOTEXT

the Macho man's (bad) joke book

Copyright © NICOTEXT 2008 All rights reserved.
NICOTEXT part of Cladd media ltd.
www.nicotext.com
info@nicotext.com

Printed in Poland
ISBN: 978-91-85869-31-2

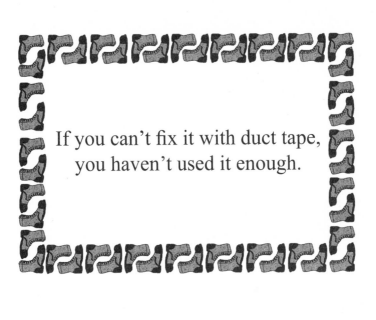

If you can't fix it with duct tape,
you haven't used it enough.

A blonde and a brunette are out driving. The brunette tells the blonde to look out for cops, especially cops with their lights on. After they've been driving for a while, the brunette asks the blonde if she can see any cops.

"Yes" says the blonde.

"Are their lights on?"

The blonde has to think for a moment, then says,

"Yes. No. Yes. No. Yes. No."

You know you're a redneck when your stair-master has an ashtray!

How many men does it take to open a beer?
None. It should be opened when she brings it.

Little Martin is four years old. One day while he was pestering his mother, she said, "Why don't you go across the street and watch the builders work, maybe you will learn something."

Martin was gone about two hours. When he came home, his mother asked him what he had learned. Martin replied - "Well, first you put the goddamn door up. Then the son of a bitch doesn't fit so you have to take the cocksucker down. Then you have to shave a cunt hair off each side and put the mother fucker back up".

Martin's mother said, "Wait until your father gets home".

When Martin's father got home, Martin's mum told him to ask Martin what he had learnt today. When Martin had told him the whole story, his dad said, "Martin, go outside and get me a switch".

Martin replied, "Get fucked. That's the electrician's job".

Why do women close their eyes during sex?
They can't stand to see a man have a good time.

A man and his wife went to their honeymoon place for their 25th anniversary. As the couple reflected on that magical evening 25 years ago, the wife asked the husband: "When you first saw my naked body in front of you, what was going through your mind?" He replied, "All I wanted to do was to fuck your brains out and suck your tits dry".

Then, as the wife undressed, she asked, "What are you thinking now?" He replied, "It looks like I did a pretty good job".

A man decided to have a facelift for his birthday. He spends $5,000 and feels really good about the result. On his way home he stops at a newsstand and buys a paper. Before leaving he says to the sales clerk, "I hope you don't mind me asking, but how old do you think I am?"

"About 35" was the reply.

"I'm actually 47" the man says happily. A little while later he goes to McDonald's for lunch and asks the order taker the same question, to which the reply is, "I'd guess that you're 29?"

"Nope, I am actually 47". He's starting to feel really good about himself. While standing at the bus stop he asks an old woman the same question. She replies, "I am 85 years old and my eyesight is going. But when I was young there was a sure way of telling a man's age. If I put my hand down your pants and play with your penis for ten minutes I will be able to tell your exact age".

As there was no one else around the man thought "what the hell?" and let the woman slip her hand down his pants. Ten minutes later the old lady says, "OK, it's done. You are 47". Stunned the man says, "That was brilliant! How did you do that?"

The old lady replies, "I was behind you in McDonald's".

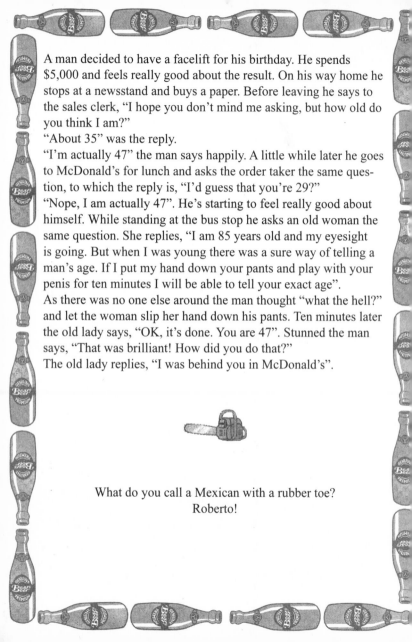

What do you call a Mexican with a rubber toe?
Roberto!

A lawyer is driving in his Mercedes and passes a field where a man is on his hands and knees chewing on the grass. He is so perplexed by this that he turns around and goes back to ask the man what the deal is. The man says, "I'm so poor, I can't afford food for my family or I, so I eat grass to survive". The lawyer says, "My word, man. I can help you get something to eat. Get in". The man is so happy, he jumps into the car. "Where is your family?" asks the lawyer. The man points yonder to where his wife and two kids are munching on a different part of the field. The lawyer swings by and picks them up. The whole family is so elated and grateful that the man has to ask the lawyer, "Are you sure this is going to be alright?"

The lawyer says, "Oh, are you kidding? You'll be thrilled. My lawn is fucking HUGE".

A guy gets pulled over for speeding. The cop walks up to his window and asks, "What's the hurry?"

"I'm late for work," answers the guy. "I'm an asshole stretcher."

"Really?" asks the cop. "What's that?"

"Well, we take assholes and slowly get our fingers inside and stretch and stretch and stretch them until they're six foot," answers the guy.

"Ok," says the cop, "and what the hell do you do with a six foot asshole?"

"Give him a radar gun and stick him at the bottom of an overpass..."

Don't forget to tip the waitress...and then help her back up.

Little Red Riding Hood is headed to Grandma's house with a basket of goodies. As she's skipping down the road, a little fawn leaps out in front of her, "Little Red! Oh Little Red! Don't go to Grandma's house! The wolf is there! He's going to rip off your blouse and fondle your breasts".

Little Red Riding Hood replies, "Oh no he's not" and goes back to skipping down the road.

A little while later, two little forest birds excitedly swoop down in front of her. "Little Red! Little Red! Don't go to Grandma's house! The wolf is there! He's going to rip off your blouse and fondle your breasts!"

Little Red Riding Hood smiles, "Oh no he's not" and continues skipping down the path.

Finally, she gets to Grandma's house and the Big Bad Wolf jumps out and says, "Little Red Riding Hood. You know what I'm going to do to you? I'm going to rip off your blouse and fondle your breasts".

Little Red Riding Hood pulls a .357 out of her basket, holds it up to the wolf and says, "Oh no you're not, you're going to eat me, just like the story says!"

So I said to the gym instructor "Can you teach me to do the splits?"
He said, "How flexible are you?"
I said, "I can't make Tuesdays".

A woman accompanied her husband to the doctor's office. After the check-up, the doctor took the wife aside and said, "If you don't do the following, your husband will surely die".

1. Each morning, fix him a healthy breakfast and send him off to work in a good mood.

2. At lunchtime, make him a warm, nutritious meal and put him in a good frame of mind before he goes back to work.

3. For dinner, fix an especially nice meal, and don't burden him with household chores.

4. Have sex with him several times a week and satisfy his every whim.

On the way home, the husband asked his wife what the doctor had told her. "You're going to die" she replied.

What does a woman say after her third orgasm?
What, you don't know?

How many mice does it take to screw in a light bulb?
Two, if they can get inside.

What two things in the air can make a woman pregnant?
Her legs.

A mother is baking cookies for her three daughters.
As she takes them out of the oven, one daughter asks her mom,
"Why did you name me Rose, mommy?"
"Because when you were born, a Rose fell on your head dear",
the mom replies.
Satisfied, the daughter takes a cookie and walks off.
Hearing the question, her second daughter approaches.
"Why did you name me Lilly, mommy?"
"Because when you were born, a Lilly fell on your head dear".
Again, satisfied with the answer, the daughter takes a cookie and
walks off.
The third daughter then approaches her mother.
"RAAAggghahhAHHHHggggHHHgghhaaaggg".
"Oh, be quiet, Fridge!"

A seal walks into a club.

A news reporter is interviewing a pirate; she asks the pirate "Why do you have a hook for a hand?"

The pirate says "Well one day, me and my brother were sword fighting and he chopped my hand off!"

Then the news reporter asks the pirate "Why do you have that patch on your eye?"

The pirate answers, "I was standing on the ship's deck one day and I looked up and a seagull pooped right in my eye!"

So the reporter then asks "How can you lose an eye or go blind just by a bird pooping in your eye?"

The pirate answers: "It's quite easy when you've only had a hook for one day!"

A guy walks into a pub and sees a sign hanging over the bar which reads:
Cheese Sandwich: $1.50
Chicken Sandwich: $2.50
Hand job: $5.00

Checking his wallet for the necessary payment, he walks up to the bar and beckons to one of the three exceptionally attractive blondes serving drinks to an eager-looking group of men.

"Yes?" she enquires with a knowing smile, "Can I help you?"

"I was wondering", whispers the man, "are you the one who gives the hand jobs?"

"Yes" she purrs, "I am".

The man replies "Well wash your fucking hands, I want a cheese sandwich!"

Why don't blind people like to sky dive?
Because it scares the hell out of the dog.

A horny man went to his wife's bed carrying a glass of water and an aspirin.
"But I don't have a headache honey!" she said.
"Gotcha!"

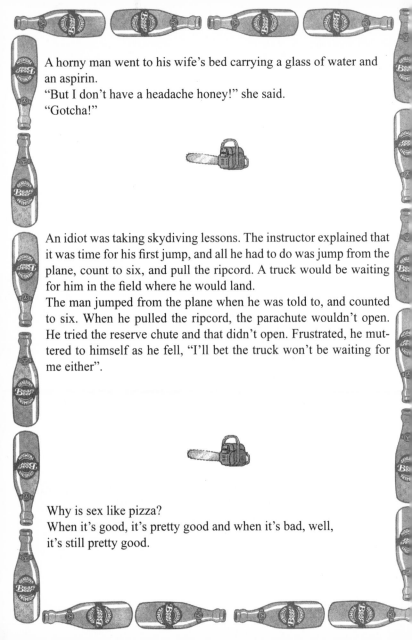

An idiot was taking skydiving lessons. The instructor explained that it was time for his first jump, and all he had to do was jump from the plane, count to six, and pull the ripcord. A truck would be waiting for him in the field where he would land.

The man jumped from the plane when he was told to, and counted to six. When he pulled the ripcord, the parachute wouldn't open. He tried the reserve chute and that didn't open. Frustrated, he muttered to himself as he fell, "I'll bet the truck won't be waiting for me either".

Why is sex like pizza?
When it's good, it's pretty good and when it's bad, well, it's still pretty good.

Why did Snoop Dogg need an umbrella?
Fo Drizzle

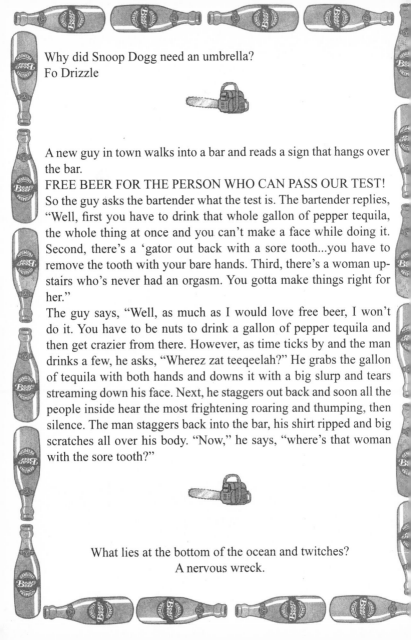

A new guy in town walks into a bar and reads a sign that hangs over the bar.

FREE BEER FOR THE PERSON WHO CAN PASS OUR TEST!

So the guy asks the bartender what the test is. The bartender replies, "Well, first you have to drink that whole gallon of pepper tequila, the whole thing at once and you can't make a face while doing it. Second, there's a 'gator out back with a sore tooth...you have to remove the tooth with your bare hands. Third, there's a woman upstairs who's never had an orgasm. You gotta make things right for her."

The guy says, "Well, as much as I would love free beer, I won't do it. You have to be nuts to drink a gallon of pepper tequila and then get crazier from there. However, as time ticks by and the man drinks a few, he asks, "Wherez zat teeqeelah?" He grabs the gallon of tequila with both hands and downs it with a big slurp and tears streaming down his face. Next, he staggers out back and soon all the people inside hear the most frightening roaring and thumping, then silence. The man staggers back into the bar, his shirt ripped and big scratches all over his body. "Now," he says, "where's that woman with the sore tooth?"

What lies at the bottom of the ocean and twitches?
A nervous wreck.

An alien walks into a bar and sits next to a drunk guy and begins poking him in the shoulder. The drunk guy just ignores him. After a wile the guy turns to the alien and begins looking him up and down. He notices that the alien has no genitalia.

He then asks "You guys have no genitalia, how do you have sex?"

The alien, still poking him in the arm, just smiles.

How do you know when a woman is about to say something smart?

When she starts a sentence with "A man once told me..."

A blonde has just gotten a new sports car. She cuts out in front of a semi, and almost causes it to drive over a cliff. The driver furiously motions for her to pull over, and she does. The driver gets out, draws a circle on the ground and tells her to stand in it. Then he gets out his knife and cuts up her leather seats. He turns around and sees she's smiling. So he goes to his truck, takes out a baseball bat, and starts busting her windows and beating her car. He looks back to see that she's laughing. He's really mad now, so he takes his knife and slices her tires. He turns around and she's laughing so hard, she's about to fall down. "What's so funny?" he demands. She says, "Every time you weren't looking, I stepped out of the circle!"

Why do gorillas have big nostrils?
Because they have big fingers.

A doctor was addressing a large audience in Tampa. "The material we put into our stomachs is enough to have killed most of us sitting here, years ago. Red meat is awful. Soft drinks corrode your stomach lining. Chinese food is loaded with MSG. High fat diets can be disastrous, and none of us realizes the long-term harm caused by the germs in our drinking water. But there is one thing that is the most dangerous of all and we all have, or will, eat it. Can anyone here tell me what food it is that causes the most grief and suffering for years after eating it?"

After several seconds of quiet, a 75 year-old man in the front row raised his hand, and softly said "wedding cake".

Why did the lawyer cross the road?
To see if the chicken had whiplash.

A construction worker on the 5th floor of a building needs a handsaw. He spots another worker on the ground floor and yells down to him, but he can't hear him. So the worker on the 5th floor tries sign language. He pointed to his eye meaning "I", pointed to his knee meaning "need", then moved his hand back and forth in a hand saw motion. The man on the ground floor nods his head, pulls down his pants, whips out his chop and starts masturbating. The worker on 5th floor gets so pissed off he runs down to the ground floor and says, "What the fuck is your problem? I said I needed a hand saw!" The other guy says, "I knew that! I was just trying to tell you – "I'm coming!"

What's big and grey and if it fell out of a tree it would kill you?
A castle.

A beautiful, voluptuous woman went to a gynecologist. The doctor took one look at this woman and all his professionalism went out the window. He immediately told her to undress. After she disrobed the doctor began to stroke her thigh. Doing so, he asked her, "Do you know what I'm doing?"

"Yes," she replied, "you're checking for any abrasions or dermatological abnormalities".

"That's right" said the doctor. He then began to fondle her breasts. "Do you know what I'm doing now?" he asked.

"Yes," the woman said, "you're checking for any lumps or breast cancer".

"Correct" replied the shady doctor.

Finally, he mounted his patient and started having sexual intercourse with her. He asked, "Do you know what I'm doing now?"

"Yes," she said. "You're getting herpes".

What did the Jewish pedophile ask the little girl?
"Hey, little girl, you want to buy some candy?"

Jesus, Moses and an old man are golfing. Moses slices the ball into a water trap. He parts the waters, walks in, and hits the ball onto the green. Jesus slices the ball into the water, walks out onto the water, and hits the ball onto the green. The old man slices the ball and it almost goes into the water trap. But right before it does, a fish leaps out of the water and grabs the ball. Before the fish can fall back into the water, an eagle comes down and grabs the fish. The eagle flies off but is struck by lightning as it gets over the green. The eagle drops the fish, which drops the ball, and the ball goes right into the hole for a hole-in-one. Jesus turns to the old man and says, "Nice shot, dad."

What do you call an Amish guy with his hand up a horse's ass?
A mechanic.

What do you call a horse that is lost?
A horse off course.

A blind man and his guide dog enter a bar and find their way to a barstool. After ordering a drink and sitting there for a while, the blind guy yells to the bartender, "Hey, you wanna hear a blonde joke?" The bar immediately becomes absolutely quiet. In a husky, deep voice, the woman next to him says, "Before you tell that joke, you should know something. The bartender is blonde, the bouncer is blonde and I'm a 6" tall, 200 lb. blonde with a black belt in karate. What's more, the woman sitting next to me is blonde and she's a weight lifter. The lady to your right is a blonde, and she's a pro wrestler. Think about it seriously, Mister. You still wanna tell that joke?"

The blind guy thinks a moment and says, "Nah, not if I'm gonna have to explain it five times".

Why did they cancel the hockey game of lepers?
Because there was a face off in the corner.

Apple announced today that it has developed a breast implant that can store and play music. The iTit will cost $499 or $599 depending on size. This has been hailed as a major breakthrough because women are always complaining about men staring at their breasts and not listening to them.

What has four legs and an arm?
A happy Rottweiler.

A guy named Bob receives a free ticket to the FA Cup Final from his company. Unfortunately, when Bob arrives at the stadium he realizes the seat is in the last row in the corner of the stadium.

About halfway through the first half, Bob notices an empty seat 5 rows off the pitch right on the halfway line. He decides to take a chance and makes his way through the stadium and around the security guards to the empty seat.

As he sits down, he asks the elderly gentleman sitting next to him, "Excuse me, is anyone sitting here?" The man says no.

Now, very excited to be in such a great seat for the game, Bob again inquires of the man next to him, "This is incredible! Who in their right mind would have a seat like this for the Cup Final and not use it?" The man replies, "Well, actually, the seat belongs to me, I was supposed to come with my wife, but she passed away. This is the first Cup Final we haven't been to together since we got married in 1962".

"Well, that's really sad," says Bob, "but still, couldn't you find someone to take the seat? A relative or a close friend?"

"No," the man replies, "they're all at the funeral".

What's worse than a Male Chauvinist Pig?
A woman who won't do what she's told.

Why do men die before their wives?
They want to.

An old lady in a nursing home is wheeling up and down the halls in her wheelchair, making sounds like she's driving a car. As she's going down the hall, an old man jumps out of a room and says, "Excuse me ma'am but you were speeding. Can I see your driver's license?"

She digs around in her purse a little, pulls out a candy wrapper, and hands it to him. He looks it over, gives her a warning and sends her on her way. Up and down the halls she goes again. Again, the same old man jumps out of a room and says, "Excuse me ma'am but I saw you cross the centre line back there. Can I see your registration please?"

She digs around in her purse a little, pulls out a store receipt and hands it to him. He looks it over, gives her another warning and sends her on her way. She zooms off again up and down the halls, weaving all over. As she comes to the old man's room again he jumps out. This time, he's stark naked and has an erection!

The old lady in the wheel chair looks up and says, "Oh no! Not the Breathalyzer again!"

A guy meets a girl out at a nightclub and she invites him back to her place for the night, her parents are out of town and this is the perfect opportunity. They get back to her house and they go into her bedroom. When the guy walks in the door, he notices a huge amount of fluffy toys. There's hundreds of them: fluffy toys on top of the wardrobe, fluffy toys on the bookshelf and window sill, there's more on the floor, and of course fluffy toys all over the bed. Later, after they've had sex, he turns to her and asks, "So, how was I?"

She says, "Well, you can take anything from the bottom shelf".

A woman in a bar says she wants to have plastic surgery to enlarge her breasts.

Her husband tells her, "Hey, you don't need surgery to do that. I know how to do it without surgery."

The lady asks, "How do I enlarge my breasts without surgery?"

"Just rub toilet paper between them."

Startled the lady asks, "How does that make them bigger?"

"I don't know, but it worked for your ass".

What insect is good at math?
An account-ant.

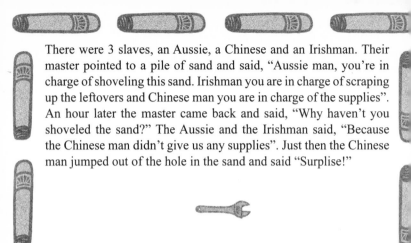

There were 3 slaves, an Aussie, a Chinese and an Irishman. Their master pointed to a pile of sand and said, "Aussie man, you're in charge of shoveling this sand. Irishman you are in charge of scraping up the leftovers and Chinese man you are in charge of the supplies". An hour later the master came back and said, "Why haven't you shoveled the sand?" The Aussie and the Irishman said, "Because the Chinese man didn't give us any supplies". Just then the Chinese man jumped out of the hole in the sand and said "Surplise!"

What do you call a boomerang that does not come back?
A stick.

One morning there was a little red man that got out of his little red bed, went up his little red stairs into his little red shower, got his little red soap and washed his little red body. Then he got out of his little red shower and put his little red towel around his waist. Then he heard his little red doorbell ring, so he went to his little red door and opened it and there was his little red newspaper. Then he picked it up and dropped his little red towel and there was a little red lady over on the footpath. She saw him naked so she ran across the road and got hit by a car.
The moral of the story is, never cross the road when the little red man is flashing.

Where is the best place to have a bubblegum contest?
On a chew chew train.

Jesus and Moses come back to Earth. They're in a rowboat in the middle of the Red Sea talking. Moses asks Jesus,
"You know, I wonder if I can still perform miracles?"
Jesus replies, "I don't know, just try".
So Moses takes his staff, touches the water, and behold, it splits in half just like it did before. Then Jesus takes his turn. He wants to walk on water like he did before, so he steps out of the boat and onto the water and starts to drown. Moses saves him and brings him back into the boat.
Jesus says, "Gee I wonder why it worked for you and not me?"
Moses replies, "What do you expect? You've got holes in your feet!"

What do you get when you cross a lawyer with a Godfather?
An offer you can't understand.

Two men were digging a ditch on a very hot day. One said to the other, "Why are we down in this hole digging a ditch when our boss is up there in the shade of a tree?"

"I don't know," replied the other, "I'll go ask him".

So he climbed out of the hole and went to his boss.

"Why are we digging in the hot sun and you're standing in the shade?"

"Intelligence" the boss said.

"What's intelligence?" asked the digger.

The boss said, "I'll show you. I'll put my hand on this tree and I want you to hit it with your fist as hard as you can". The ditch digger took a mighty swing and tried to hit the boss' hand. The boss removed his hand and the ditch digger hit the tree. The boss said, "That's intelligence!"

The ditch digger went back to his hole. His friend asked, "What'd he say?"

"He said we are down here because of intelligence".

"What's intelligence?" his friend asked.

The ditch digger put his hand on his face and said, "Take your shovel and hit my hand".

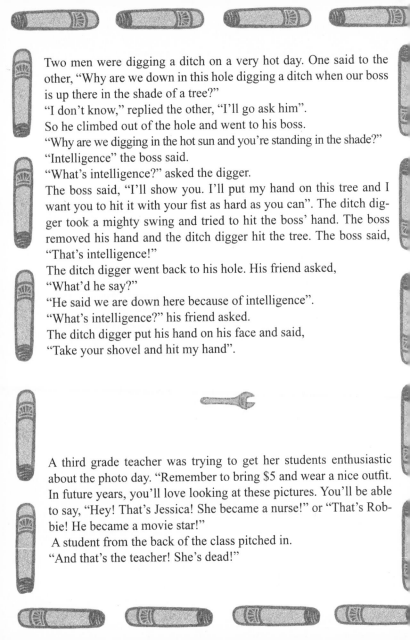

A third grade teacher was trying to get her students enthusiastic about the photo day. "Remember to bring $5 and wear a nice outfit. In future years, you'll love looking at these pictures. You'll be able to say, "Hey! That's Jessica! She became a nurse!" or "That's Robbie! He became a movie star!"

A student from the back of the class pitched in.

"And that's the teacher! She's dead!"

PROOF THAT JESUS WAS JEWISH

1) He went into his father's business.
2) He lived at home until the age of 33.
3) He was sure his mother was a virgin, and his mother was sure he was God.

PROOF THAT JESUS WAS IRISH

1) He never got married.
2) He never held a steady job.
3) His last request was a drink.

PROOF THAT JESUS WAS PUERTORICAN

1) His first name was Jesus.
2) He was always in trouble with the law.
3) His mother did not know who his father was.

PROOF THAT JESUS WAS BLACK

1) He called everybody "brother".
2) He had no permanent address.
3) Nobody would hire him.

PROOF THAT JESUS WAS CALIFORNIAN

1) He never cut his hair.
2) He walked around barefoot.
3) He invented a new religion.

PROOF THAT JESUS WAS FRENCH

1) He never changed his clothes.
2) He only washed his feet.
3) He didn't speak English.

PROOF THAT JESUS WAS BRAZILIAN

1) He survived on miracles.
2) He was harassed by the government and politicians.
3) He never had any money.

What did the rabbit say when he fell into a hole filled with water?
"Oh, well."

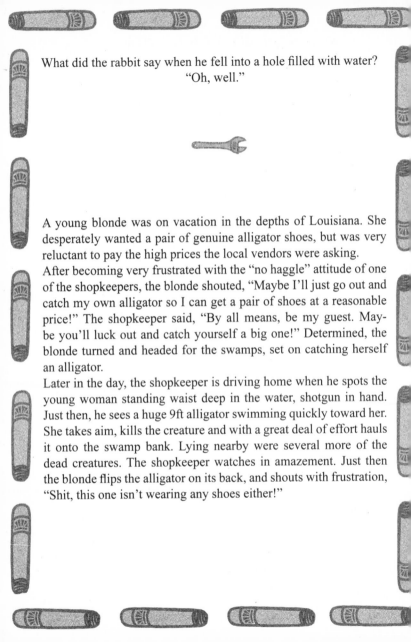

A young blonde was on vacation in the depths of Louisiana. She desperately wanted a pair of genuine alligator shoes, but was very reluctant to pay the high prices the local vendors were asking.

After becoming very frustrated with the "no haggle" attitude of one of the shopkeepers, the blonde shouted, "Maybe I'll just go out and catch my own alligator so I can get a pair of shoes at a reasonable price!" The shopkeeper said, "By all means, be my guest. Maybe you'll luck out and catch yourself a big one!" Determined, the blonde turned and headed for the swamps, set on catching herself an alligator.

Later in the day, the shopkeeper is driving home when he spots the young woman standing waist deep in the water, shotgun in hand. Just then, he sees a huge 9ft alligator swimming quickly toward her. She takes aim, kills the creature and with a great deal of effort hauls it onto the swamp bank. Lying nearby were several more of the dead creatures. The shopkeeper watches in amazement. Just then the blonde flips the alligator on its back, and shouts with frustration, "Shit, this one isn't wearing any shoes either!"

What's the difference between love and herpes?
Love doesn't last forever.

John invited his mother over for dinner. During the meal, his mother couldn't help noticing how handsome John's roommate was. She had long been suspicious of John's sexual orientation and this only made her more curious.

Over the course of the evening, while watching the two interact, she started to wonder if there was more between John and the roommate than met the eye.

Reading his mom's thoughts, John volunteered, "I know what you must be thinking, but I assure you, Mark and I are just roommates".

About a week later, Mark came to John and said, "Ever since your mother came to dinner, I've been unable to find the beautiful silver gravy ladle. You don't suppose she took it, do you?"

John said, "Well, I doubt it, but I'll write her a letter just to be sure". So he sat down and wrote:

Dear Mother, I'm not saying you "did" take a gravy ladle from my house, and I'm not saying you "did not" take a gravy ladle. But the fact remains that one has been missing ever since you were here for dinner.

Several days later, John received a letter from his mother that read:

Dear Son, I'm not saying that you "do" sleep with Mark, and I'm not saying that you "do not" sleep with Mark. But the fact remains that if he was sleeping in his own bed, he would have found the gravy ladle by now.

Love, Mom.

What do the letters D.N.A. stand for?
National Dyslexics Association.

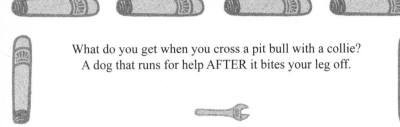

What do you get when you cross a pit bull with a collie?
A dog that runs for help AFTER it bites your leg off.

A Blonde Year
JANUARY - Took new scarf back to store because it was too tight.
FEBRUARY - Fired from pharmacy job for failing to print labels...
duh! Bottles won't fit in typewriter!
MARCH - Got excited...finished jigsaw puzzle in 6 months...
box said "2-4 years"!
APRIL - Trapped on escalator for hours...power went out!
MAY - Tried to make Kool-Aid...8 cups of water won't fit into
those little packets!
JUNE - Tried to go water skiing... couldn't find a lake with a slope.
JULY - Lost breaststroke swimming competition...learned later,
other swimmers cheated, they used their arms!
AUGUST - Got locked out of car in rainstorm...car got swamped,
because the top was down.
SEPTEMBER - The capital of California is "C"...isn't it?
OCTOBER - Hate M&Ms. They are so hard to peel.
NOVEMBER - Baked turkey for 4 1/2 days...instructions said
1 hour per pound and I weigh 108!
DECEMBER – Couldn't call 911...duh! There's no "eleven"
button on the phone!
What a year!

Why did the restaurant print its bills on condoms?
So the man can stick his date with the bill.

It was the mailman's last day on the job after 35 years of carrying the mail through all kinds of weather to the same neighborhood. When he arrived at the first house on his route he was greeted by the whole family there, who congratulated him and sent him on his way with a big gift envelope. At the second house they presented him with a box of fine cigars. The folks at the third house handed him a selection of terrific fishing lures.

At the final house a strikingly beautiful blonde in a revealing negligee met him at the door. She took him by the hand, gently led him through the door (which she closed behind him), and took him up the stairs to the bedroom where she blew his mind with the most passionate sex he had ever experienced. When he'd had enough they went downstairs, where she fixed him a giant breakfast: eggs, potatoes, ham, sausage, blueberry waffles and fresh-squeezed orange juice. When he was truly satisfied she poured him a cup of steaming coffee. As she was pouring, he noticed a dollar bill sticking out from under the cup's bottom edge. "All this was just too wonderful for words," he said, " but what's the dollar for?"

"Well," she said, "last night, I told my husband that today would be your last day and that we should do something special for you. I asked him what to give you. He said, 'Screw him, give him a dollar' ." The blonde then blushed and said, "The breakfast was my idea".

What's the difference between light and hard?
You can go to sleep with the light on, but you can't go to sleep with a hard on.

There was a farmer who had three daughters. All three were asked out by three different guys on the same night. The farmer was incredibly protective of his daughters, so on that night he sat near the door with a loaded shotgun so he could judge each man to see if he had any indecent intentions for his daughters. There is a knock on the door, and the farmer opens it to see the first suitor.

"Hi, my name's Joe. I'm here for Flo. We're going to the show. Is she ready to go?" The farmer could see no reason to object, so off they went. After a while, there was a second knock on the door. "Hi, my name's Eddie. I'm here for Betty. We're going out for spaghetti. Is she ready?"

The farmer could see no reason to object, so off they went. After a while, there was a third knock on the door.

"Hi, my name's Chuck. I'm..." *BLAM!*

One day in heaven, God was feeling tired and He sat down to talk with St Peter.

"I need a vacation", said God.

"How about going to Pluto?" suggested St Peter.

"Nah, I went there twenty thousand years ago and broke my leg skiing", said God.

"Hmm… How about Mercury then?"

"Oh me, no! I went there ten thousand years ago and got really nasty sunburn".

St Peter thought for a moment.

"I know. How about going down to Earth?"

God groaned. "No way. I was there two thousand years ago and had a holiday fling with a local girl and they still haven't stopped talking about it!"

Did you hear about the guy who lost his left side?
He's all right now.

A horse and a chicken lived on a farm. The horse and the chicken were in fact two very good friends. One day the horse fell into a mud hole and could not get out. The chicken saw this and said, "What should I do? What should I do?"

The horse replied, "Go get the farmers BMW and a rope so that you can pull me out".

So, the chicken ran and got the BMW and a rope. He drove it back, tied the rope to the horse and the other end to the car. The chicken put the car in gear and pulled the horse out. "Wow", the horse said. "Thanks a lot".

So one day the chicken fell into the hole. "Help, help", he yelled. "Go get the farmers BMW and a rope to pull me out!"

The horse said, "No need. I'll just straddle the hole and you hold onto my dick and I'll pull out".

"OK" said the chicken. So the chicken grabbed hold of the horse's dick and was pulled out.

What is the MORAL of the story?

You don't need a BMW to pick up chicks, if you are hung like a horse.

I'll tell you what I love doing more than anything: trying to pack myself in a small suitcase. I can hardly contain myself.

The balloon family is in bed. During the night there's a thunderstorm and the baby balloon is scared so he goes to his parents room and tries to squeeze into their bed.

It's tiny so he lets some air out of his dad but still can't get in.
He lets some air out of his mum but he still can't get in.
Desperately, he lets a lot of air out of himself and then fits in.
In the morning his dad is furious.
"Son you've let me down, you've let your Mum down,
but most of all you've let yourself down".

In 1993, the University of Kentucky did a study to see why the head of a man's penis was larger than the shaft. After one year and $80,000 they concluded that the reason the head was larger than the shaft was to give the man more pleasure during sex. After the study was published, the University of South Carolina decided to do their own study. After $250,000 and 3 years of research, they concluded that the reason was to give the woman more pleasure during sex. The University of Georgia, unsatisfied with these findings, conducted their own study. After 2 weeks and a cost of around $75.46, they concluded that it was to keep a man's hand from flying off and hitting him in the forehead.

A dyslexic man walks into a bra...

Y2K Statement

"Our staff have completed the 18 months of work on time and on budget. We have gone through every line of code in every program in every system. We have analyzed all databases, all data files, including backups and historic archives, and modified all data to reflect the change.

We are proud to report that we have completed the "Y2K" date change mission, and have now implemented all changes to all programs and all data to reflect your new standards:

Januark, Februark, March, April, Mak, June, Julk, August, September, October, November, December.

As well as: Sundak, Mondak, Tuesdak, Wednesdak, Thursdak, Fridak and Saturdak.

I trust this is satisfactory, because to be honest, none of this "Y to K" problem has made any sense to me. But I understand it is a global problem, and our team is glad to help in any way possible".

What do a walrus and Tupperware have in common?
They both like a tight seal.

One day Jane met Tarzan in the jungle. She was very attracted to him and during her questions about his life, she asked him how he managed for sex.

"What's that?" he asked.

She explained to him what sex was and he said, "Oh, Tarzan use hole in trunk of tree".

Horrified, she said, "Tarzan you have it all wrong! I will show you how to do it properly".

She took off her clothes, laid down on the ground and spread her legs.

"Here," she said, pointing, "You must put it in here."

Tarzan removed his loincloth, stepped closer and then gave her an almighty kick in the crotch. Jane rolled around in agony. Eventually she managed to gasp, "What the hell did you do that for?"

"Tarzan check for squirrels".

Billy Bob and Luther were talking one afternoon when Billy Bob told Luther, "Ya know, I reckon I'm about ready for a vacation. Only this year I'm gonna do it a little differently. The last few years, I took your advice about where to go. Three years ago you said to go to Hawaii I went to Hawaii and Earlene got pregnant. Then two years ago, you told me to go to the Bahamas and Earlene got pregnant again. Last year you suggested Tahiti and darned if Earlene didn't get pregnant again."

Luther asked Billy Bob, "So, what are you gonna do this year that's different?"

Billy Bob says, "This year I'm taking Earlene with me".

Satan: "Why so glum?"

Guy: "What do you think? I'm in hell!"

Satan: "Hell's not so bad. We actually have a lot of fun down here. Are you a drinking man?"

Guy: "Sure, I love to drink".

Satan: "Well, you're gonna love Mondays then. On Mondays, all we do is drink. Whiskey, Tequila, Guinness, wine coolers, Tab, and Fresca. We drink 'til we throw up, and then we drink some more! And you don't have to worry about getting a hangover, because you're dead anyway".

Guy: "Gee that sounds great!"

Satan: "Are you a smoker?"

Guy: "You better believe it!"

Satan: "All right! You're gonna love Tuesdays. We get the finest cigars from all over the world, and smoke our lungs out. If you get cancer, no biggie, you're already dead, remember?"

Guy: "Wow...that's awesome!"

Satan: "I bet you like to gamble."

Guy: "Why, yes, as a matter of fact I do".

Satan: "Good, 'cause on Wednesdays you can gamble all you want. We play craps, blackjack, roulette, poker, and slots, whatever! If you go bankrupt, it doesn't matter, you're dead anyhow".

Guy: "Cool!"

Satan: "What about drugs?"

Guy: "Are you kidding? I love drugs! You don't mean...?"

Satan: "That's right! Thursday is drug day. Help yourself to a great big bowl of crack or smack. Smoke a doobie the size of a submarine. You can do all the drugs you want. You're dead so who cares?"

Guy: "Wow! I never realized hell was such a cool place!"

Satan: "Are you gay?"

Guy: "No".

Satan: "Ooooh, Fridays are gonna be tough..."

Bubba died in a fire and his body was burned pretty badly. The morgue needed someone to identify the body, so they sent for his two best friends, Cooter and Gomer. The three men had always done everything together. Cooter arrived first, and when the mortician pulled back the sheet, Cooter said, "Yup, his face is burned up pretty bad. You better roll him over".

The mortician rolled him over and Cooter said, "Nope, that aint Bubba".

The mortician thought this was rather strange. So he brought Gomer in to confirm the identity of the body.

Gomer looked at the body and said, "Yup, he's pretty well burnt up. Roll him over".

The mortician rolled him over and Gomer said, "No, that aint Bubba."

The mortician asked, "How can you tell?"

Gomer said, "Well, Bubba had two assholes".

"What? He had two assholes?" asked the mortician.

"Yup, we've never seen 'em, but everybody used to say, 'There's Bubba with those two assholes'."

How do you catch a unique rabbit?
Unique up on it.

How do you catch a tame rabbit?
Tame way, unique up on it.

A lady goes to her parish priest one day and tells him,
"Father, I have a problem. I have two female parrots but they only know how to say one thing".

"What do they say?" the priest inquired.

"They say, "Hi, we're prostitutes. Do you want to have some fun?"

"That's obscene!" the priest exclaimed, "I can see why you are embarrassed".

He thought a minute and then said, "You know, I may have a solution to this problem. I have two male parrots I've taught to pray and read the Bible. Bring your two parrots over to my house and we will put them in the cage with Francis and Job. My parrots can teach your parrots to praise and worship. I'm sure your parrots will stop saying that... that phrase in no time".

"Thank you" the woman responded, "this may very well be the solution".

The next day, she brought her female parrots to the priest's house. As he ushered her in, she saw the two male parrots were inside their cage, holding their rosary beads and praying. Impressed, she walked over and placed her parrots in with them.

After just a couple of seconds, the female parrots exclaimed out in unison, "Hi, we're prostitutes. Do you want to have some fun?"

There was a stunned silence. Finally, one male parrot looked over at the other male parrot and said, "Put the beads away, Francis, our prayers have been answered!"

Two Necrophiliacs are walking by a morgue when one turns to the other:
"Fancy popping in for a cold one?"

Three men were standing in line to get into heaven one day. Apparently it had been a pretty busy day, so St. Peter had to tell the first one, "Heaven's getting pretty close to full today, and I've been asked to admit only people who have had particularly horrible deaths. So what's your story?"

The first man replies: "Well, for a while I've suspected my wife has been cheating on me, so today I came home early to try to catch her red-handed. As I came into my 25th floor apartment, I could tell something was wrong, but all my searching around didn't reveal where this other guy could have been hiding. Finally, I went out to the balcony, and sure enough, there was this man hanging off the railing, 25 floors above ground! By now I was really mad, so I started beating on him and kicking him, but wouldn't you know it, he wouldn't fall off. So finally I went back into my apartment and got a hammer and starting hammering on his fingers. Of course, he couldn't stand that for long, so he let go and fell. After 25 stories, he fell into the bushes –stunned but okay. I couldn't stand it anymore, so I ran into the kitchen, grabbed the fridge, and threw it over the edge where it landed on him, killing him instantly. But all the stress and anger got to me, and I had a heart attack and died there on the balcony".

"That sounds like a pretty bad day to me", said Peter, and let the man in. The second man comes up and Peter explains to him about heaven being full, and again asks for his story.

"It's been a very strange day. You see, I live on the 26th floor of my apartment building, and every morning I do my exercises out on my balcony. Well, this morning I must have slipped or something, because I fell over the edge.

But I got lucky, and caught the railing of the balcony on the floor below me. I knew I couldn't hang on for very long, when suddenly this man burst out onto the balcony. I thought for sure I was saved, when he started beating on me and kicking me. I held on the best I could until he ran into the apartment and grabbed a hammer and started pounding on my hands. Finally I just let go, but again I got lucky and fell into the bushes below, stunned but all right. Just when I was thinking I was going to be okay, this refrigerator comes falling out of the sky and crushes me instantly, and now I'm here."

Once again, Peter had to concede that that sounded like a pretty horrible death and let him through.

The third man came to the front of the line, and St. Peter asked for his story.

"Picture this," says the third man, "I'm hiding naked inside a refrigerator..."

David Hasselhoff calls his agent and demands, "I want everyone to call me The Hoff from now on." His agent replies "Sure! No hassle".

Mr. Bear and Mr. Rabbit didn't like each other very much and one day, whilst they were walking through the woods they came across a golden frog. The frog turned to them and said, "Ooh, I don't often meet anyone in these parts". They were amazed that the frog had talked to them.

The golden frog admitted: "Mind you, when I do meet someone I always give them six wishes. You can have three wishes each in this case".

Mr. Bear immediately wished that all the other bears in the forest were females. The frog granted his wish.

Mr. Rabbit, after thinking for a while, wished for a crash helmet. One appeared immediately, and he placed it on his head.

Mr. Bear was amazed at Mr. Rabbit's wish, but carried on with his second wish. He wished that all the bears in the neighboring forests were females as well, and the frog granted his wish.

Mr. Rabbit then wished for a motorcycle. It appeared before him, and he climbed on board and started revving the engine.

Mr. Bear could not believe it and complained that Mr. Rabbit had wasted two wishes that he could have had for himself. Shaking his head, Mr. Bear made his final wish, that all the other bears in the world were females as well, leaving him as the only male bear in the world.

The frog replied that it had been done, and they both turned to Mr. Rabbit for his last wish.

Mr. Rabbit revved the engine, thought for a second, then said: "I wish that Mr. Bear was gay!" and rode off as fast as he could!

What kind of bee gives milk?
A BOObee.

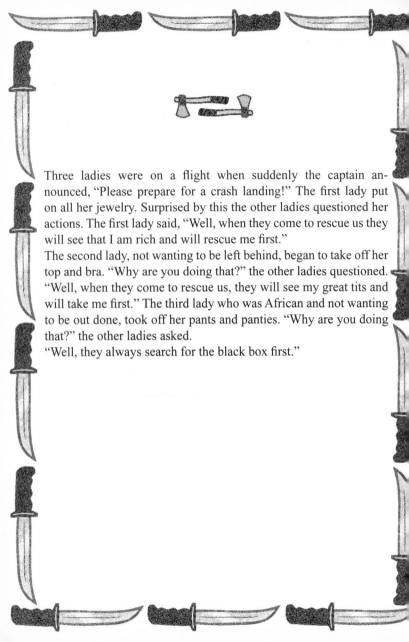

Three ladies were on a flight when suddenly the captain announced, "Please prepare for a crash landing!" The first lady put on all her jewelry. Surprised by this the other ladies questioned her actions. The first lady said, "Well, when they come to rescue us they will see that I am rich and will rescue me first."

The second lady, not wanting to be left behind, began to take off her top and bra. "Why are you doing that?" the other ladies questioned. "Well, when they come to rescue us, they will see my great tits and will take me first." The third lady who was African and not wanting to be out done, took off her pants and panties. "Why are you doing that?" the other ladies asked.

"Well, they always search for the black box first."

During the World War II, the Japanese attacked an American warship. A torpedo was heading towards the ship and a hit seemed inevitable. So the captain told the navigator to go down to the crew quarters and tell a joke or something –at least they would die laughing. The navigator went down and said to the crew, "What would you think if I could split the whole ship in two by hitting my dick against the table?" The crew burst out laughing. So the navigator pulled his dick out and whammed it on the table. Just when his dick hit the table, a huge explosion tore the ship apart. The only survivors were the captain and the navigator. As they floated around in a lifeboat captain asked the navigator, "Well, the crew really laughed. What did you do?" The navigator told him how he hit his dick against the table. The captain replied, "Well, in the future you better be careful with that dick of yours. The torpedo missed!"

On a transatlantic flight, a plane passes through a severe storm. The turbulence is awful and things go from bad to worse when one wing is struck by lightning. One woman in particular loses it. Screaming, she stands up at the front of the plane. "I'm too young to die!" she wails. "Well, if I'm going to die, I want my last minutes to be memorable! I've had plenty of sex in my life, but no one has ever made me really feel like a woman! Is there ANYONE on this plane who can make me feel like a WOMAN?" For a moment, there is silence. Everyone has forgotten their own peril, and they all stare, riveted, at the desperate woman at the front of the plane. Then, a man stands up in the rear of the plane. "I can make you feel like a woman" he says. He's gorgeous. He's tall, built, with long, flowing black hair and jet black eyes. He starts to walk slowly up the aisle, unbuttoning his shirt one button at a time. No one moves. The woman is breathing heavily in anticipation as the stranger approaches. He removes his shirt. Muscles ripple across his chest as he reaches her, and extends the arm holding his shirt to the trembling woman, and whispers, "Iron this".

1. Between the ages of 16 and 18, she is like Africa, a virgin, unexplored.

2. Between the ages of 19 and 35, she is like Asia, hot and exotic.

3. Between the ages of 36 and 45, she is like America, fully explored, breathtakingly beautiful, and free with her resources.

4. Between the ages of 46 and 56, she is like Europe, exhausted but still has points of interest.

5. After 56 she is like Australia, everybody knows it's down there but who gives a damn?

A ventriloquist walked up to an Indian and said "I'll bet I can make your horse talk".

Indian: "Horse no talk".

Ventriloquist: "Sure, watch this: Hi horse. How does your master treat you?"

Horse: "Oh, he is good to me. He gives me food, water and he keeps me out of the sun".

Ventriloquist: "I'll bet I can make you dog talk".

Indian: "Dog no talk".

Ventriloquist: "Sure watch this: Dog, how are you? Does your master treat you good?"

Dog: "Oh! He treats me good. He gives me food, water and he plays ball with me".

Ventriloquist: "I'll bet I can make your sheep talk."

Indian: "Sheep Lie! Sheep Lie!"

Two men from Texas were sitting at a bar, when a young lady nearby began to choke on a hamburger. She gasped and gagged, and one Texan turned to the other and said, "That little gal is havin' a bad time. I'm gonna go over there and help".

He ran over to the young lady, held both sides of her head in his big, Texan hands, and asked, "Kin ya swaller?" Gasping, she shook her head no. He asked, "Kin ya breathe?" Still gasping, she again shook her head no. With that, he yanked up her skirt, pulled down her panties and licked her on the butt. The young woman was so shocked that she coughed up the piece of hamburger and began to breathe on her own. The Texan sat back down with his friend and said, "Ya know, it's sure amazin' how that hind-lick maneuver always works".

Two starving bums are walking through an alley when one of them sees a dead cat. He runs over, sits down and starts to eat the cat, tearing the meat from its limbs. He says to the other bum, "Hey, I know you're hungry, too. Why don't you eat some of this cat?"

"Hell no!" replies the second bum, "That cat's been dead for days, he's all stiff and cold and smelly!" The first bum says, "Okay, suit yourself" and continues to eat everything: skin, muscle, guts, –all but the skeleton. A few hours later as they are walking down the street the first bum says, "Oh, I don't feel so good. I think there might have been something wrong with that cat". And just then, he pukes up a huge puddle of rotten cat flesh and guts with stomach bile mixed in, all half digested and looking like mush. The second bum sits down next to the puddle and says, "Now you're talking! It's been months since I had a WARM meal!"

A panda walks into a bar and asks the bartender for a meal. When the meal finally arrives, he eats it quickly, then shoots a drunk, and leaves the bar.

A patron walks over to the bartender and asks,

"What was that all about?"

The bartender replies, "Look up 'panda' in the dictionary, pal."

The patron retrieves his Webster's dictionary from his coat pocket and looks up the word 'panda'.

"What's it say?" asks the bartender.

The patron replies with a grin, "Eats shoots and leaves".

A guy walks into a bar carrying an 18 foot alligator. The bartender says, "What do think you're doing? Get that goddamn thing out of here. I don't allow pets in my establishment". The guy tries to explain. "Look, he won't cause any trouble. He's well trained and I'll prove it". He then proceeds to put the alligator on the bar and says, "open". The alligator open its mouth and you can see all of its razor sharp teeth. "Now watch this", he says and proceeds to remove his penis through his zipper and lays his balls gently onto the alligator's teeth. He then orders a beer and proceeds to drink it. All the while the alligator keeps its mouth open and nothing happens. After finishing the beer the man gently removes his penis and puts it back into his pants. He then says, "close" and the alligator closes its mouth. "You see he is perfectly trained. He would do that for anybody. Does anyone want to try?" After looking around he finally hears a drunk at a nearby table say "Sure I'd like to try. But I don't know if I can keep my mouth open that long".

A father walks into a bookstore with his three years old son. The boy has a coin in one hand. Suddenly, the boy starts choking and turning blue in the face. The father realizes the boy has swallowed the coin and starts shouting for help.

An attractive woman, in a blue business suit is sitting at the coffee bar, reading a newspaper and sipping a cup of coffee. At the sound of the commotion, she looks up; puts down the cup, neatly folds the paper and places it on the counter, then gets up and makes her way unhurriedly across the store.

Reaching the boy, the woman carefully drops his pants, takes hold of his testicles and starts to squeeze and twist, gently at first, then ever so firmly. After a few seconds the boy convulses violently and coughs up the coin, which the woman deftly catches in her free hand.

Releasing the child's testicles, the woman hands the coin to the father and, without a word, returns to her coffee and paper. As soon as he is sure that his son has suffered no ill effects, the father rushes over to the woman and starts thanking her, saying, "I've never seen anybody do anything like that before, it was fantastic! Are you a doctor?"

"No" the woman replied. "Divorce attorney".

What do Alexander the Great and Kermit the Frog have in common?
Their middle names.

Did you hear about that new movie, *Constipated*?

No.

Oh, it hasn't come out yet.

A plane is on its way to Detroit when a blonde woman in economy class gets up and moves into an open seat in the first class section.

The flight attendant watches her do this, and politely informs the woman that she must sit in economy class because that's the type of ticket she paid for.

The blonde replies, "I'm blonde, I'm beautiful, I'm going to Detroit and I'm staying right here".

After repeated attempts and no success at convincing the woman to move, the flight attendant goes into the cockpit and informs the pilot and co-pilot that there's a blonde bimbo sitting in first class who refuses to go back to her economy seat. The co-pilot goes back to the woman and explains why she needs to move, but once again the woman replies by saying, "I'm blonde, I'm beautiful, I'm going to Detroit and I'm staying right here".

The co-pilot returns to the cockpit and suggests that perhaps they should have the arrival gate call the police and have the woman arrested when they land. The pilot says, "You say she's blonde? I'll handle this. I'm married to a blonde. I speak blonde". He goes back to the woman and whispers quietly in her ear, and she says, "Oh, I'm sorry" then quickly moves back to her seat in economy class.

The flight attendant and co-pilot are amazed and ask him what he said to get her to move back to economy without causing any fuss.

"I told her first class isn't going to Detroit".

A man worked at an orange juice factory.
Unfortunately, he was canned because he couldn't concentrate.

The mother-in-law stopped by unexpectedly at the newlyweds' house. She rang the doorbell and stepped into the house. She saw her daughter-in-law standing naked by the door.

"What are you doing?" she asked.

"I'm waiting for my husband to come home from work" the daughter-in-law answered.

"But you're naked!" the mother-in-law exclaimed.

"This is my love dress" the daughter-in-law explained.

"Love dress? But you're naked!"

"My husband loves me to wear this dress! It makes him happy and it makes me happy. I would appreciate it if you would leave because he will be home from work any minute".

The mother-in-law was tired of all this romantic talk and left. On the way home she thought about the love dress. When she got home she undressed, showered, put on her best perfume and waited by the front door. Finally her husband came home. He walked in and saw her standing naked by the door.

"What are you doing?" he asked.

"This is my love dress" she replied.

"Needs ironing" he said.

One day Joe was walking across a building site and saw his foreman pouring coffee from a thermos flask.

"What's that you have there foreman?" Joe asked.

"A thermos flask," said the foreman.

"And what does that do?" asked Joe.

"Well," said the foreman, "if you put anything hot in it, it stays hot, and if you put anything cold in it, it stays cold".

"That's fantastic!" said Joe. "I must get myself one of those".

The next day Joe sat eating his lunch when his friend Mick came in.

"What's that you have there Joe?" asked Mick.

"A thermos flask" replied Joe.

"And what does that do?" asked Mick.

"Well," said Joe, "if you put anything hot in it, it stays hot, and if you put anything cold in it, it stays cold".

"That's marvelous" Mick exclaimed. "And what have you got in there now?"

"Well," said Joe, "I've got two cups of coffee and an ice-cream".

What did the Buddhist say to the hotdog seller?
Make me one with everything!

99% of lawyers give the rest a bad name.

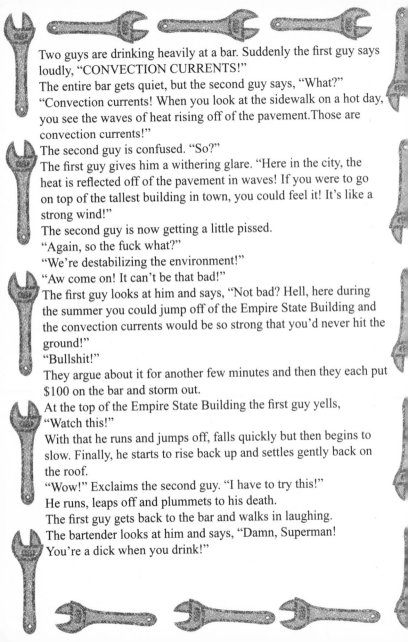

Two guys are drinking heavily at a bar. Suddenly the first guy says loudly, "CONVECTION CURRENTS!"

The entire bar gets quiet, but the second guy says, "What?"

"Convection currents! When you look at the sidewalk on a hot day, you see the waves of heat rising off of the pavement. Those are convection currents!"

The second guy is confused. "So?"

The first guy gives him a withering glare. "Here in the city, the heat is reflected off of the pavement in waves! If you were to go on top of the tallest building in town, you could feel it! It's like a strong wind!"

The second guy is now getting a little pissed.

"Again, so the fuck what?"

"We're destabilizing the environment!"

"Aw come on! It can't be that bad!"

The first guy looks at him and says, "Not bad? Hell, here during the summer you could jump off of the Empire State Building and the convection currents would be so strong that you'd never hit the ground!"

"Bullshit!"

They argue about it for another few minutes and then they each put $100 on the bar and storm out.

At the top of the Empire State Building the first guy yells, "Watch this!"

With that he runs and jumps off, falls quickly but then begins to slow. Finally, he starts to rise back up and settles gently back on the roof.

"Wow!" Exclaims the second guy. "I have to try this!"

He runs, leaps off and plummets to his death.

The first guy gets back to the bar and walks in laughing.

The bartender looks at him and says, "Damn, Superman! You're a dick when you drink!"

What's the ultimate rejection?
When you're masturbating and your hand falls asleep.

A man was walking along a Florida beach and stumbled across an old lamp. He picked it up and rubbed it and out popped a genie. The genie said, "OK, You released me from the lamp, blah blah blah. This is the fourth time this month, and I'm getting a little sick of these wishes so you can forget about three... You only get one wish!"

The man sat, and thought about it for a while and said, "I've always wanted to go to Hawaii, but I'm scared to fly, and I get very seasick. Could you build me a bridge to Hawaii so I can drive over there to visit?"

The genie laughed and said, "That's impossible! Think of the logistics of that! How would the supports ever reach the bottom of the Pacific? Think of how much concrete, how much steel! No, think of another wish". The man said, "OK, I'll try to think of a really good wish". Finally, he said, "I've been married and divorced four times. My wives always said that I don't care and that I'm insensitive. So, I wish that I could understand women, know how they feel inside, and what they're thinking when they give me the silent treatment. I want to know why they're crying, know what they really want when they say 'nothing', know how to make them truly happy".

The genie said, "Do you want that bridge to be two lanes or four?"

An old farmer decided it was time to get a new rooster for his hens. The current rooster was still doing an okay job, but he was getting on in years and the farmer figured getting a new rooster couldn't hurt. So he bought a new cock from the local rooster emporium, and turned him loose in the barnyard. When the old rooster saw the young one strutting around, he became a little worried about being replaced. He walked up to the new bird and said, "So you're the new stud in town? I bet you really think you're hot stuff don't you? Well I'm not ready for the chopping block yet. I'll bet I'm still the better bird. To prove it, I challenge you to a race around that hen house over there. We'll run around it ten times and whoever finishes first gets to have all the hens for himself". The young rooster was a proud sort, and he definitely thought he was more than a match for the old guy. "You're on" he said, "and since I'm so great, I'll even give you a head start of half a lap. I'll still win easily!" So the two roosters went over to the henhouse to start the race with all the hens gathering to watch. When the race began, all the hens started cheering the old rooster on. After the first lap, the old rooster was still maintaining his lead. After the second lap, the old guy's lead has slipped a little –but he was still hanging in there. Unfortunately, the old rooster's lead continued to slip each time around, and by the fifth lap, he was just barely in front of the young fella. By now the farmer had heard the commotion. Figuring a fox or something was after his chickens, he ran into the house, got his shotgun and ran into the barnyard. When he got there, he saw the two roosters running around the henhouse, with the old rooster still slightly in the lead. He immediately took his shotgun, aimed, fired, and blew the young rooster away. "Damn. That's the third gay rooster I've bought this month."

If the pilgrims were alive today, what would they best be known for?
Their age.

A little boy came down to breakfast. Since he lived on a farm, his mother asked if he had done his chores.

"Not yet" said the little boy. His mother told him he couldn't have any breakfast until he did his chores. The little boy was a little pissed, so when he went to feed the chickens, he kicked one of them. Then he went to feed the cows, and kicked one of the cows while he was at it. He then went to feed the pigs, and kicked one of them too.

The little boy then went back inside for breakfast and his mother gave him a bowl of dry cereal. "How come I don't get any eggs or bacon? And why don't I have any milk in my cereal?" he asked.

"Well," his mother said, "I saw you kick a chicken, so you don't get any eggs. I saw you kick the pig, so you don't get any bacon, either. I also saw you kick the cow, so you aren't getting any milk this morning".

Just about then, his father came down for breakfast and he kicked the cat on his way into the kitchen. The little boy looks up at his mother with a smile, and says, "Are you going to tell him, or should I?"

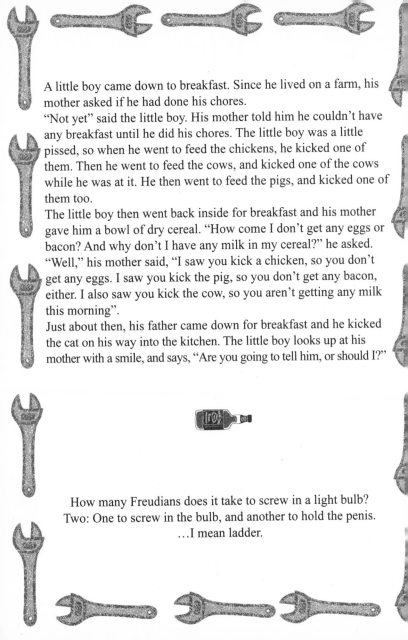

How many Freudians does it take to screw in a light bulb?
Two: One to screw in the bulb, and another to hold the penis.
…I mean ladder.

A guy walked into a bar with his pet monkey and ordered a drink. While he was drinking, the monkey jumped all around the place. It grabbed some olives off the bar and ate them, then grabbed some sliced limes and ate them. It jumped onto the pool table, took one of the billiard balls, stuck it in his mouth and to everyone's amazement, somehow swallowed it whole.

The bartender screamed at the guy, "Did you see what your monkey just did?"

The guy said, "No, what?"

"He just ate a billiard ball off my pool table...whole!"

"Yeah, that doesn't surprise me," replied the guy, "he eats everything in sight. Sorry, I'll pay for the cue ball and stuff". He finished his drink, paid his bar bill and paid for the stuff the monkey ate and walked out.

Two weeks later he came into the bar again along with his monkey. He ordered a drink and the monkey started running around the bar as before. While the man was finishing his drink, the monkey found a maraschino cherry on the bar. He grabbed it, stuck it up his butt, then pulled it out and ate it. Then he found a peanut which he also stuck up his butt, pulled out and ate.

The bartender was disgusted "Did you see what your monkey did now?" he asked.

"No, what?" replied the guy.

"Well, he stuck a maraschino cherry up his butt, pulled it out and ate it...the same with the peanut!"

"Yeah, that doesn't surprise me" said the guy. "He still eats everything in sight, but ever since he had to pass that cue ball, he measures everything first".

This is a compilation from actual student exams

1. Ancient Egypt was inhabited by mummies and they all wrote in hydraulics. They lived in the Sarah Dessert and traveled by Camelot. The climate of the Sarah is such that the inhabitants have to live elsewhere.

2. The Bible is full of interesting caricatures. In the first book of the Bible, Guinessis, Adam and Eve were created from an apple tree. One of their children, Cain, asked, "Am I my brother's son?"

3. Moses led the Hebrew slaves to the Red Sea, where they made unleavened bread which is bread made without any ingredients. Moses went up on Mount Cyanide to get the Ten Commandments. He died before he ever reached Canada.

4. Solomom had three hundred wives and seven hundred porcupines.

5. The Greeks were a highly sculptured people, and without them we wouldn't have history. The Greeks also had myths. A myth is a female moth.

6. Actually, Homer was not written by Homer but by another man of that name.

7. Socrates was a famous Greek teacher who went around giving people advice. They killed him. Socrates died from an overdose of wedlock. After his death, his career suffered a dramatic decline.

8. In the Olympic games, Greeks ran races, jumped, hurled the biscuits, and threw the java.

9. Eventually, the Romans conquered the Greeks. History calls people Romans because they never stayed in one place for very long.

10. Julius Caesar extinguished himself on the battlefields of Gaul. The Ides of March murdered him because they thought he was going to be made king. Dying, he gasped out: "Tee hee, Brutus."

11. Nero was a cruel tyranny who would torture his subjects by playing the fiddle to them.

12. Joan of Arc was burnt to a steak and was cannonized by Bernard Shaw. Finally Magna Carta provided that no man should be hanged twice for the same offense.

13. In midevil times most people were alliterate. The greatest writer of the futile ages was Chaucer, who wrote many poems and verses and also wrote literature.

14. Another story was William Tell, who shot an arrow through an apple while standing on his son's head.

15. Queen Elizabeth was the "Virgin Queen". As a queen she was a success. When she exposed herself before her troops they all shouted "hurrah".

16. It was an age of great inventions and discoveries. Gutenberg invented removable type and the Bible. Another important invention was the circulation of blood. Sir Walter Raleigh is a historical figure because he invented cigarettes and started smoking. And Sir Francis Drake circumcised the world with a 100-foot clipper.

17. The greatest writer of the Renaissance was William Shakespeare. He was born in the year 1564, supposedly on his birthday. He never made much money and is famous only because of his plays. He wrote tragedies, comedies, and hysterectomies, all in Islamic pentameter. Romeo and Juliet are an example of a heroic couplet. Romeo's last wish was to be laid by Juliet.

18. Writing at the same time as Shakespeare was Miguel Cervantes. He wrote Donkey Hote. The next great author was John Milton. Milton wrote Paradise Lost. Then his wife died and he wrote Paradise Regained.

19. During the Renaissance America began. Christopher Columbus was a great navigator who discovered America while cursing about the Atlantic. His ships were called the Nina, the Pinta, and the Santa Fe.

20. Later, the Pilgrims crossed the ocean, and this was called Pilgrim's Progress. The winter of 1620 was a hard one for the settlers. Many people died and many babies were born. Captain John Smith was responsible for all this.

21. One of the causes of the Revolutionary War was the English put tacks in their tea. Also, the colonists would send their parcels through the post without stamps. Finally the colonists won the War and no longer had to pay for taxis. Delegates from the original 13 states formed the Contented Congress. Thomas Jefferson (a Virgin) and Benjamin Franklin were two singers of the Declaration of Independence. Franklin discovered electricity by rubbing two cats backwards and declared, "A horse divided against itself cannot stand". Franklin died in 1790 and is still dead.

22. Soon the Constitution of the United States was adopted to secure domestic hostility. Under the constitution the people enjoyed the right to keep bare arms.

23. Abraham Lincoln became America's greatest Precedent. Lincoln's mother died in infancy, and he was born in a log cabin that he built with his own hands. Abraham Lincoln freed the slaves by signing the Emasculation Proclamation. On the night of April 14, 1865, Lincoln went to the theater and got shot in his seat by one of the actors in a moving picture show. The believed assinator was John Wilkes Booth, a supposedly insane actor. This ruined Booth's career.

24. Meanwhile in Europe, the enlightenment was a reasonable time. Voltaire invented electricity and also wrote a book called Candy.

25. Gravity was invented by Issac Walton. It is chiefly noticeable in the autumn when the apples are falling off the trees.

26. Johann Bach wrote a great many musical compositions and had a large number of children. In between he practiced on an old spinster that he kept up in his attic. Bach died from 1750 to the present. Bach was the most famous composer in the world and so was Handel. Handel was half German half Italian and half English. He was very large.

27. Beethoven wrote music even though he was deaf. He was so deaf he wrote loud music. He took long walks in the forest even when everyone was calling for him. Beethoven expired in 1827 and later died for this.

28. The French Revolution was accomplished before it happened and catapulted into Napoleon. Napoleon wanted an heir to inherit his power, but since Josephine was a baroness, she couldn't have any children.

29. The sun never set on the British Empire because the British Empire is In the East and the sun sets in the West.

30. Queen Victoria was the longest queen. She sat on a thorn for 63 years. She was a moral woman who practiced virtue. Her death was the final event that ended her reign.

31. The nineteenth century was a time of a great many thoughts and inventions. People stopped reproducing by hand and started reproducing by machine. The invention of the steamboat caused a network of rivers to spring up. Cyrus McCormick invented the McCormick raper, which did the work of a hundred men.

32. Louis Pasteur discovered a cure for rabbis. Charles Darwin was a naturalist who wrote the Organ of the Species. Madman Curie discovered radio. And Karl Marx became one of the Marx brothers.

33. The First World War, caused by the assignation of the Arch-Duck by an anahist, ushered in a new error in the anals of human history.

Why did the hedgehog cross the road?
To visit his flat mate!

The day after his wife disappeared in a kayaking accident, an Anchorage man answered his door to find two grim-faced Alaska state troopers.

"We're sorry Mr. Wilkes, but we have some information about your wife" said one trooper.

"Tell me! Did you find her?" Wilkes shouted.

The troopers looked at each other. One said, "We have some bad news, some good news, and some really great news. Which do you want to hear first?"

Fearing the worst, an ashen Mr. Wilkes said, "Give me the bad news first".

The trooper said, "I'm sorry to tell you, sir, but this morning we found your wife's body in Kachemak Bay".

"Oh my God!" exclaimed Wilkes. Swallowing hard, he asked, "What's the good news?"

The trooper continued, "When we pulled her up she had 12 twenty-five pound king crabs and 6 good-size Dungeness crabs clinging to her". Stunned, Mr. Wilkes demanded, "If that's the good news, what's the great news?"

The trooper said, "We're going to pull her up again tomorrow".

A woman suspects her husband is cheating on her. One day, she dials her home and a strange woman answers. The woman says, " Who is this?"
"This is the maid" answers the other woman.
"We don't have a maid", says the woman.
The maid replies, "I was hired this morning by the man of the house.
The woman then says, "Well, this is his wife. Is he there?"
The maid replies, "He is upstairs in the bedroom with someone who I figured was his wife".
The woman is fuming. She says to the maid, "Listen, would you like to make $50,000?"
The maid says, "What will I have to do?"
The woman tells her, "I want you to get my gun from the desk, and shoot the jerk and the witch he's with."
The maid puts the phone down; the woman hears footsteps and the gunshots.
The maid comes back to the phone, "What do I do with the bodies?"
The woman says, "Throw them in the swimming pool".
Puzzled, the maid answers, "But there's no pool here".
After a long pause the woman says, "Is this 832-4821?"

A little old lady goes into the store to do some shopping. She is bewildered over the large selection of toilet paper. "Pardon me, sir," she says to the store manager, "but can you explain the differences in all these toilet papers?"

"Well," he replies pointing out one brand, "this is as soft as a baby's bottom. It's $1.50 per roll". He grabs another and says, "This is nice and soft, strong but gentle, and it's $1.00 a roll". Pointing to the bottom shelf he tells her, "We call that our No Name brand, and it's 20 cents per roll".

"Give me the No Name," she says.

She comes back about a week later, seeks out the manager and says, "Hey! I've got a name for your No Name toilet paper. I call it John Wayne."

"Why?" he asks.

"Because it's rough, it's tough and it don't take crap from anybody!"

For decades two heroic statues, one male and one female, faced each other in a city park. One day an angel came down from heaven and approached the statues. "You've been such exemplary statues," the angel announced to them, "so I'm going to give you a special gift. I'm going to bring you both to life for thirty minutes, in which you can do anything you want". And with a clap of his hands, the angel brought the statues to life.

The two approached each other a bit shyly, but soon dashed into the bushes, from where shortly could be heard a good deal of giggling, laughter, and shaking of branches.

Fifteen minutes later, the two statues emerged from the bushes, wide grins on their faces. "You still have fifteen more minutes" said the angel, winking at them. Grinning widely the female statue turned to the male statue and said, "Great! Only this time you hold the pigeon down and I'll crap on its head!"

One evening a drunk walks into a bar, sits down, and happens to notice a 12" tall man standing on the bar. Astonished, the man asks the guy next to him; "What the hell is that?"

The guy next to him replies, "He's a pianist!"

To which the drunk replied, "Horse shit, you're pulling my leg".

So the guy next to him picks up the 12" man, grabs some books, and props him up at the piano. Sure enough, this little man started hammering out all the favorite tunes of the bars' patrons.

Stunned, the drunk asks "That little guy is cool, where the hell did you get him?"

The guy told the drunk how he had found a genie bottle out in the alley, rubbed it until a genie appeared, and was granted one wish.

All of a sudden the drunk hauls ass out the back door, finds the bottle, and starts rubbing it: when all of a sudden a genie pops out and grants him one wish.

In a slur, the drunk asks, "I wish for a million bucks". All of a sudden, the sky turns black and overhead a million ducks come flying overhead shitting all over him.

Angrily, the drunk runs back inside, slams the door and begins cursing, "You son of a bitch, I found that genie bottle and wished for a million bucks and all of a sudden there are a million ducks shitting all over my new suit".

The guy started laughing and wildly exclaimed "You don't really think I wished for a 12" pianist do you?

How can you confuse a blonde?
Put her in a round room and tell her to sit in the corner.

A guy is lying in his hospital bed, wired up with drips and monitors, breathing with the aid of an oxygen mask. A young lady goes round the ward with the tea and newspaper trolley. Approaching him, she asks if there is anything she can do for him. The guy looks at her and asks "Are my testicles black?"

"I'm sorry but I'm not medical staff, I can't help you with that" she replies.

"Oh, please have a look for me, I'm really worried. Are my testicles black?"

Taking pity on his obvious distress the girl glances around the ward and, seeing there are no medical staff around, says "Alright, I'll have a look for you". She pulls back the bedcover, lifts his dick out of the way and cups his balls in her hand. With a note of relief in her voice she tells him, "No, they look fine to me".

The patient pulls off his oxygen mask and says, "I said, ARE MY TEST RESULTS BACK?"

Why don't oysters give to charity?
Because they're shellfish.

A man observed a woman in the grocery store with a three-year-old girl in her basket. As they passed the cookie section, the little girl asked for cookies and her mother told her "No". The little girl immediately began to whine and fuss, and the mother said quietly, "Now Monica, we just have half of the aisles left to go through. Don't be upset, it won't be long now". Soon, they came to the candy aisle and the little girl began to shout for candy. When told she couldn't have any, she began to cry. The mother said, "There, there, Monica, don't cry. There are only two more aisles to go and then we'll be checking out".

When they got to the checkout stand, the little girl immediately began to clamor for gum. Upon discovering there'd be no gum purchased, she burst into a terrible tantrum. The mother said serenely, "Monica, we'll be through this check out stand in 5 minutes and then you can go home and have a nice nap". The man followed them out to the parking lot and stopped the woman to compliment her. "I couldn't help noticing how patient you were with little Monica" he began.

The mother replied, "I'm Monica - my little girl's name is Tammy".

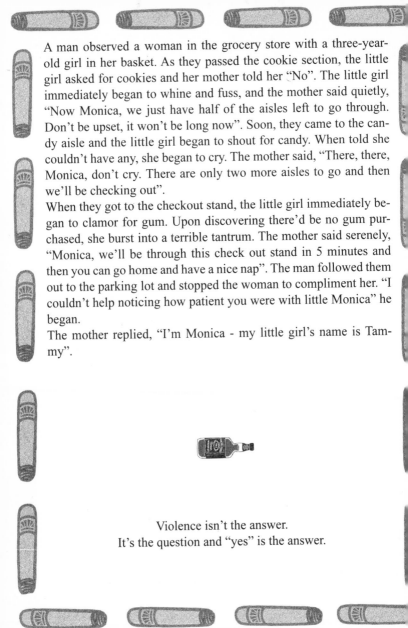

Violence isn't the answer.
It's the question and "yes" is the answer.

A guy walks into a bar, orders a scotch and soda and puts a frog on the bar. The bartender gives him the drink and asks what the frog is for.

The guy snaps his fingers and the frog jumps down and blows the man. The bartender is amazed, and asks to see that again.

So the guy snaps his fingers a second time and the frog jumps down, blows the man, and hops back on the bar. The bartender is astounded, he offers the guy $3000 for the frog. The man of course accepts, and gives the frog to the bartender.

After his shift, the bartender goes home. He sits in his kitchen and calls his wife over. "I have something to show you," he says.

His wife walks in and the bartender takes the frog out of his pocket. He puts it on the table and snaps his fingers. The frog jumps down, blows the bartender and hops back on the kitchen table.

The wife asks, "Why the hell are you showing me this?"

The bartender says, "cause you're going to teach him how to cook and then you're gonna get the fuck outta here".

What did the blonde do when she heard that 90% of accidents occur around the home?

She moved.

A guy stops to visit his friend who is paralyzed from the waist down. His friend says, "My feet are cold. Would you get me my sneakers for me?" The guy goes upstairs, and there are his friend's two gorgeous daughters. He says, "Hi, girls. Your dad sent me up here to fuck you". The first daughter says, "That's not true". He says, "I'll prove it". He yells down the stairs, "Both of them?" His friend yells back, "Of course, both of them".

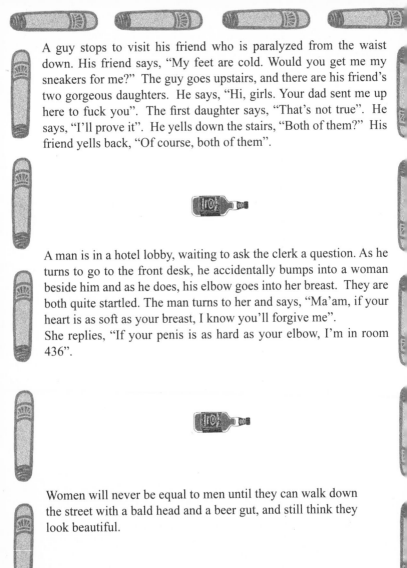

A man is in a hotel lobby, waiting to ask the clerk a question. As he turns to go to the front desk, he accidentally bumps into a woman beside him and as he does, his elbow goes into her breast. They are both quite startled. The man turns to her and says, "Ma'am, if your heart is as soft as your breast, I know you'll forgive me".
She replies, "If your penis is as hard as your elbow, I'm in room 436".

Women will never be equal to men until they can walk down the street with a bald head and a beer gut, and still think they look beautiful.

How do most men define marriage?
An expensive way to get laundry done for free.

If you want your wife to listen and pay undivided attention to every word you say, talk in your sleep.

A man once said, "I never knew what real happiness was until I got married; then it was too late".

The most effective way to remember your wife's birthday is to forget it once.

How do you get a Kleenex to dance?
Put a little boogie in it!

Psychiatrist to chicken:
"Why do YOU think you cross the road?"

What did one hat say to the other hat?
"You stay here I'm gonna go on a head!"

What time is it when an elephant sits on a fence?
Time to buy a new fence.

Two cannibals meet one day. The first cannibal says, "You know, I just can't seem to get a tender missionary. I've baked them, I've roasted them, I've stewed them, I've barbecued them, I've tried every sort of marinade. I just can't seem to get them tender".

The second cannibal asks, "What kind of missionary do you use?"

The other replies, "You know, the ones that hang out at that place at the bend of the river. They have those brown cloaks with a rope around the waist and they're sort of bald on top with a funny ring of hair on their heads".

"Ah, ha!" the second cannibal replies. "No wonder, those are FRIARS!"

Why did Elton John take his boyfriend to the funeral?
So at least one old queen would be seen crying in public.

A couple went on vacation to a fishing resort up north. The husband liked to fish at the crack of dawn; the wife preferred to read. One morning the husband returned after several hours of fishing and decided to take a short nap. The wife decided to take the boat out. She was not familiar with the lake so she rowed out, anchored the boat, and started reading her book. Along came the sheriff in his boat, pulled up alongside her and said, "Good morning, Ma'am. What are you doing?"

"Reading my book" she replied as she thought to herself, "Is this guy blind or what?"

"You're in a restricted fishing area", he informed her.

"But, Officer, I'm not fishing. Can't you see that?"

"Well, you have all this equipment, Ma'am. I'll have to take you in and write you up."

"If you do that I will charge you with rape!" snapped the irate woman.

"I didn't even touch you" groused the sheriff.

"Yes, that's true, but you have all the equipment."

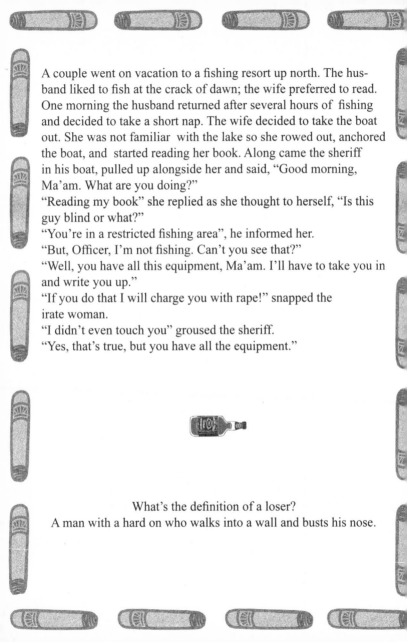

What's the definition of a loser?
A man with a hard on who walks into a wall and busts his nose.

An eagle was feeling rather horny, so he swooped down on a dove and took it back to his nest. Once back at the nest the dove said, "I'm a dove and I like love".

The eagle thought, "Fuck that!" and tossed the dove out of the nest.

Then the eagle spotted an owl. So he swooped down on the owl and took it back to his nest. Once back at the nest the owl said, "I'm an owl and I like to howl". The eagle thought, "Fuck that!" and tossed the owl out of the nest. Then the eagle spotted a duck. So he swooped down on the duck and took it back to his nest. Once back at the nest the duck said, "I'm a drake and I think you've made a mistake!"

Where do baby cows eat?
The calf-eteria.

What do the Twilight Zone and the New York Sewer System
have in common?
DOODOODOODOODOO!

A tribe in the Amazon jungle captures three explorers. The chief is going to punish the intruders. He calls the first explorer to the front of the tribe and asks, "Death or Booka?" The explorer doesn't want to die, so he opts for booka. The tribe starts dancing around and screaming BOOKA! The chief then rips the explorers pants off and fucks him in the ass. The chief calls the second explorer to the front and asks, "Death or Booka?" Well not wanting to die either, he opts for Booka. The tribe again starts dancing around and screaming BOOKA! The chief rips the second guys pants off and fucks him in the ass. The chief calls the third explorer to the front and asks, "Death or Booka?" Well the third guy has a little more self-respect and thinks death would be better than being violated in front of hundreds of tribesman, so he opts for death. The chief turns to the tribe and screams "DEATH BY BOOKA!"

There once were two asparagus plants that decided to pull up roots and go to the other side of the road. One made it, the other was hit by a car.

At the hospital, the doctor approached the non-injured asparagus and says, "I've got good news and bad news. The good news is, your friend will live. The bad news is, he'll be a vegetable for the rest of his life".

A man came home to find his wife packing.
"Where are you going?" he asked.
"To Las Vegas, I found out that a girl can make $150 for doing what I do for free with you."
He also then began packing, saying, "I'm going to Vegas too. I want to see how you can live on $150 a month!"

What goes clop, clop, clop, bang, bang, clop clop clop?
An Amish drive-by shooting.

A young teenage girl was a prostitute and for obvious reasons, kept it a secret from her grandma. One day, the police raided a brothel and arrested a group of prostitutes, including the young girl. The prostitutes were instructed to line up in a straight line on the sidewalk. Well, who should be walking in the neighborhood, but little old Grandma. The young girl was frantic. Sure enough, Grandma noticed her young grand-daughter and asked curiously, "What are you lining up for, dear?" Not willing to let grandma in on her little secret, the young girl told her that some people were passing out free oranges and that she was lining up for some.

"Mmm, sounds lovely" said Grandma. "I think I'll have some myself," and she made her way to the back of the line. A police officer made his way down the line, questioning all of the prostitutes. When he got to Grandma at the end of the line, he was bewildered. "But you're so old... how do you do it?"

Grandma replied, "Oh, it's quite easy, sonny... I just remove my dentures and suck 'em dry!"

Do you know the punishment for bigamy?
Two mother in laws.

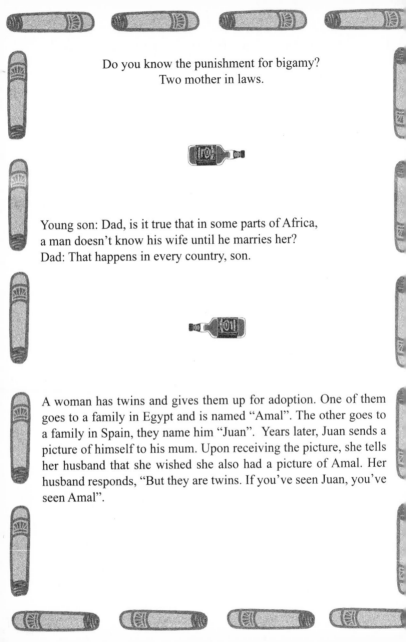

Young son: Dad, is it true that in some parts of Africa,
a man doesn't know his wife until he marries her?
Dad: That happens in every country, son.

A woman has twins and gives them up for adoption. One of them
goes to a family in Egypt and is named "Amal". The other goes to
a family in Spain, they name him "Juan". Years later, Juan sends a
picture of himself to his mum. Upon receiving the picture, she tells
her husband that she wished she also had a picture of Amal. Her
husband responds, "But they are twins. If you've seen Juan, you've
seen Amal".

A man goes into a fish and chip shop with a salmon under his arm.
He asks, "Do you sell fish cakes here?"
"No" was the reply.
"Shame, it's his birthday."

How are a Texas tornado and a Tennessee divorce the same?
Somebody's gonna lose a trailer.

A ship carrying red paint collided with another carrying blue paint.
What happened?
Both crews were marooned.

A new car has been designed especially for the Los Angeles rush hour.
It's called a stationary wagon.

I rear-ended a car this morning. When the driver got out of the other car, I looked down and saw he was a dwarf. He looked up at me and yelled, "I'M NOT HAPPY!"
So I asked him, "Well then, which one are you?"

What's the difference between a bad golfer and a bad skydiver? A bad golfer goes whack, damn. A bad skydiver goes damn, whack.

What did the mother buffalo say to her child as he left for school? Bison!

An 86-year-old man went to his doctor for his quarterly check-up.
The doctor asked him how he was feeling and the 86-year-old said,
"Things are great and I've never felt better. I now have a 20 year-old bride
who is pregnant with my child. So what do you think about that Doc?"
The doctor considered his question for a minute and then began to tell a story.
"I have an older friend, much like you, who is an avid hunter and never
misses a season. One day he was setting off to go hunting. In a bit of a
hurry, he accidentally picked up his walking cane instead of his gun. As
he neared a lake, he came across a very large male beaver sitting at the
water's edge. He realized he'd left his gun at home and so he couldn't
shoot the magnificent creature. Out of habit he raised his cane, aimed it
at the animal as if it were his favorite hunting rifle and went bang, bang.
Miraculously, two shots rang out and the beaver fell over dead. Now,
what do you think of that?" asked the doctor. The 86-year-old said,
"Logic would strongly suggest that somebody else pumped a couple of
rounds into that beaver.
"My point exactly", replied the doctor.

Two Eskimos sitting in a kayak were chilly; but when they lit a fire in
the craft, it sank, proving once and for all that you can't have your kayak
and heat it.

Legend has it that there is a bar in New York in which a very special mirror hangs on the wall of the ladies room. If one stands in front of the mirror and tells the truth, one wish is granted. If one tells a lie however, then with a "POOF!" you are instantly swallowed up by the mirror, never to be seen again. So, a redhead of questionable looks walks into the ladies room and stands before the mirror and says, "I think I'm the most beautiful woman in the world".

POOF! The mirror swallows her.

Next, a rather large brunette stands before the mirror and says, "I think I'm the sexiest woman alive".

POOF! The mirror swallows her.

Then an absolutely gorgeous blonde comes in and stands before the mirror and says, "I think. . . ."

POOF!

A man walks into a bar and sits beside a little man. The little man asks if he has a family and how old he is. The man tells him he his 29 and has a wife and two kids.

The little man says "I am a Leprechaun, and if you left me fuck you in the butt I will grant you three wishes".

They go to the bathroom and the Leprechaun starts fucking him in the butt. When he's almost finished the Leprechaun says, "You did say you had a family right?"

Than man replies, "Yes I'm 29 and have a wife and two kids".

The Leprechaun says, "Well aren't you a little bit old to be believing in Leprechauns?"

Got some bad news.... I've caught that bird flu. I know it's bird flu because I've started talking bollocks, wearing make up and I can't park the fucking car!

What's the difference between pussy and parsley?
Nobody eats parsley.

Friction: It's such a drag.

Southern birth control:

After their 11th child, an Alabama couple decided that they'd had enough children, as they could not afford a larger bed. So the husband went to his veterinarian and told him that he and his cousin didn't want to have any more children. The doctor told him that there was a procedure called a vasectomy that could fix the problem but that it was expensive. "A less costly alternative," said the doctor, "is to go home, get a cherry bomb, (fireworks are legal in Alabama) light it, put it in a beer can, then hold the can up to your ear and count to 10".

The Alabamian said to the doctor, "I may not be the smartest tool in the shed, but I don't see how putting a cherry bomb in a beer can next to my ear is going to help me".

"Trust me" said the doctor.

So the man went home, lit a cherry bomb and put it in a beer can. He held the can up to his ear and began to count:

"1...2...3...4...5..." At which point he paused, placed the beer can between his legs and continued counting on his other hand.

This procedure also works in Tennessee, Kentucky and Louisiana.

A teacher is explaining biology to her 1st grade students. "Human beings are the only animals that stutter", she says.

A little girl raises her hand and says, "I had a kitty-cat who stuttered". The teacher, knowing how precious some of these stories could become, asked the girl to describe the incident.

"Well," she began, "I was in the back yard with my kitty and the Rottweiler that lives next door got a running start and before we knew it, he had jumped over the fence into our yard!"

"That must've been scary", said the teacher.

"It sure was" said the little girl.

"My kitty raised his back and went 'Fffffff, Fffffff, Fffffff. Fffffff', and before he could say 'Fuck', the Rottweiler ate him."

An Eskimo is out for a drive one day when his car breaks down and he is forced to call out the Alaskan AA. The Eskimo stands in the howling wind and waits for the mechanic to arrive. When the mechanic reaches the broken car, he sets to work, looking under the bonnet until he appears to have located the problem.

He looks up at the Eskimo and says, "You've blown a seal, mate". To which the Eskimo hastily replies, "No, I haven't. That's just frost on my moustache".

A guy walks into a bar with a piece of concrete, goes to the bartender and says, "Two drinks. One for me and one for the road".

Why did the one handed man cross the road?
Because the second-hand store was across the street.

An Irishman, a Mexican and a blonde guy are working on a skyscraper. One day while at lunch, the Irishman opens up his lunchbox and sighs.

"If I get another lunch of corned beef and cabbage, I swear I am going to jump off this tower."

Then the Mexican opens his lunchbox and sighs.

"If I get another taco for lunch, I swear I'm going to jump off this tower."

Then the blonde guy opens his lunch and sighs.

"If I get another baloney sandwich, I swear I'm going to jump off this tower."

The next day, the Irishman gets corned beef and cabbage and he plunges to his death.

The Mexican gets a taco and he plunges to his death.

The blonde guy gets a baloney sandwich and he plunges to his death.

At the funeral, all three of their wives are weeping. The Irishman's wife says, "He could have told me that he was tired of corned beef and cabbage! I could have made something else!"

The Mexican's wife said, "He could have told me that he was tired of tacos! I could have made something else!"

They then look at the blonde guy's wife, who says, "Don't look at me. He made his own lunches".

If your dog is barking at the back door and your wife is yelling at the front door, whom do you let in first?

The dog, of course: He'll shut up once you let him in.

Why did the blonde try and steal a police car?
She saw "911" on the back and thought it was a Porsche.

Three guys were fishing at a lake in the summer, when one of them fell in. After rescuing him from the bottom, the first guy gave him mouth-to-mouth resuscitation. "Man, this guy has really bad breath!" he exclaimed. "I can't revive him, you try!"

The second guy took his turn. "Man, you're right, he does have raunchy bad breath, and I don't remember this snowmobile suit either"!

A young ventriloquist is touring the clubs and stops to entertain at a bar in a small town. He's going through his usual run of silly blonde jokes when a big blonde woman in the fourth row stands on her chair and says, "OK jerk, I've heard just about enough of your denigrating blonde jokes. What makes you think you can stereotype women that way? What do a person's physical attributes have to do with their worth as a human being? It's guys like you who keep women like me from being respected at work and in my community, of reaching my full potential as a person, because you and your kind continue to perpetuate discrimination against not only blondes but women at large, all in the name of humor".

Flustered, the ventriloquist begins to apologize, when the blonde pipes up, "You stay out of this mister, I'm talking to that little fucker on your knee!"

80,000 blondes meet for the annual "Blondes Are Not Stupid Convention". Jessica Simpson (the guest speaker) gets up and says: "We are all here today to prove to the world that blondes are not stupid. Can I have a volunteer?"

A blonde gingerly works her way through the crowd and steps up to the stage. Jessica asks her, "What is 5 plus 5?"

After 15 or 20 seconds she says, "Eighteen!"

Obviously everyone is a little disappointed.

Then 80,000 blondes start cheering, "Give her another chance! Give her another chance!"

Jessica says, "Well since we've gone to the trouble of getting 80,000 of you in one place and we have the world-wide press and global broadcast media here, gee, uh, I guess we can give her another chance." So she asks, "What is 3 plus 2?"

After nearly 30 seconds she eventually says, "Ninety?"

Jessica is quite perplexed, looks down and just lets out a dejected sigh. Everyone is disheartened, the blonde starts crying and the 80,000 girls begin to yell and wave their hands shouting, "GIVE HER ANOTHER CHANCE! GIVE HER ANOTHER CHANCE!"

Jessica, unsure whether or not she is doing more harm than good, eventually says, "Ok! Ok! Just one more chance. What is 2 plus 2?"

The girl closes her eyes, and after a whole minute eventually says, "Four?". Throughout the stadium pandemonium breaks out as all 80,000 girls jump to their feet, wave their arms, stomp their feet and scream...

"GIVE HER ANOTHER CHANCE! GIVE HER ANOTHER CHANCE!"

How can you tell a macho woman?
She kick starts her vibrator and rolls her own tampons.

A young blonde woman is distraught because she fears her husband is having an affair, so she goes to a gun shop and buys a handgun. The next day she comes home to find her husband in bed with a beautiful redhead. She grabs the gun and holds it to her own head. The husband jumps out of bed, begging and pleading with her not to shoot herself. Hysterically the blonde responds to the husband, "Shut up...you're next!"

There was a papa mole, a mama mole, and a baby mole. They lived in a hole out in the country near a farmhouse. Papa mole poked his head out of the hole and said, "Mmmm, I smell sausage!"
Mama mole poked her head outside the hole and said,
"Mmmm, I smell pancakes!"
Baby mole tried to stick his head outside but couldn't because of the two bigger moles.
Baby mole said, "The only thing I smell is molasses."

A police officer pulls a bloke over for speeding and has the following exchange:

Officer: May I see your driver's license?

Driver: I don't have one. I had it suspended for speeding.

Officer: May I see the registration for this vehicle?

Driver: It's not my car. I stole it.

Officer: The car is stolen?

Driver: That's right. But come to think of it, I think I saw the registration in the glove box when I was putting my gun in there.

Officer: There's a gun in the glove box?

Driver: Yes mate. That's where I put it after I shot and killed the woman who owns this car and stuffed her in the boot.

Officer: There's a BODY in the BOOT?

Driver: Yes, mate.

Hearing this, the officer immediately called his back up. Police quickly surrounded the car, and the inspector approached the driver to handle the tense situation:

Inspector: Sir, can I see your license?

Driver: Sure. Here it is.

It was valid.

Captain: Whose car is this?

Driver: It's mine, officer. Here are the registration papers.

Captain: Could you slowly open your glove box so I can see if there's a gun in it?

Driver: Yes, sir, but there's no gun in it.

Sure enough, there was nothing in the glove box.

Captain: Would you mind opening your boot? I was told you said there's a body in it.

Driver: No problem.

The boot is opened and sure enough, there is no body.

Captain: I don't understand it. The officer who stopped you said you told him you didn't have a license, stole the car, had a gun in the glove box, and that there was a dead body in the boot.

Driver: Yeah, I'll bet the lying bastard told you I was speeding as well.

Bob had a blonde friend named Becky.

Becky called Bob up one night...

"Bob, you've GOT to come over and help me. I started a jigsaw puzzle and I can't even put the first two pieces together."

Bob said, "Well, Becky, what is the puzzle supposed to look like?"

"The picture on the box is a tiger", said Becky.

"I'll be there in ten minutes to help", answered Bob.

Bob gets to Becky's house and sits on the couch. The puzzle is on the coffee table. Bob says, "Well Becky, I think you need to make yourself some decaf. After that I'll help you put all these frosted flakes back in the box".

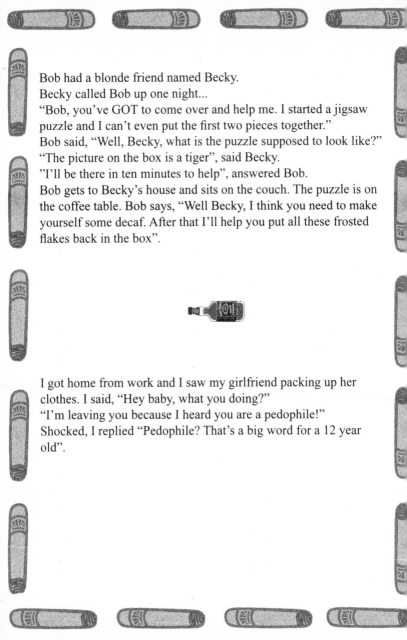

I got home from work and I saw my girlfriend packing up her clothes. I said, "Hey baby, what you doing?"

"I'm leaving you because I heard you are a pedophile!"

Shocked, I replied "Pedophile? That's a big word for a 12 year old".

Goldie was sitting on a beach in Florida, attempting to strike up a conversation with the attractive gentleman reading on the blanket beside hers. "Hello sir," she said, "do you like movies?"

"Yes, I do," he responded, then returned to his book.

Goldie persisted. "Do you like gardening?"

The man again looked up from his book. "Yes, I do" he said politely before returning to his reading.

Undaunted, Goldie asked. "Do you like pussycats?"

With that, the man dropped his book and pounced on Goldie, making love to her like she'd never been made love to before. As the cloud of sand began to settle, Goldie dragged herself to a sitting position and panted, "How did you know that was what I wanted?" The man thought for a moment and replied, "How did you know my name was Katz?"

What did the Spanish farmer say to his chickens?
Oh-lay!

What did one ovary say to the other ovary?
Did you order a piano?
There are two nuts here trying to shove in an organ!

A guy was sitting at a bar when his friend asked, "Frank, what would you do if you came home and found a guy humping your wife?"
"I'd break his white cane, trash his wheelchair and call the home he escaped from!"

Did you hear about the new deodorant called Umpire?
It's for foul balls.

What's the difference between a women's track team and a tribe of smart pygmies?
The pygmies are a tribe of cunning runts.

What's the difference between a sorority girl and a Rolls Royce?
Most men have never been in a Rolls Royce.

A guy put a cat in a microwave oven and now everything he cooks in it tastes like pussy.

How can you tell if your wife is dead?
The sex is the same but the dishes pile up.

The last fight we had was my fault. My wife asked, "What's on the TV?", and I said, "Dust!"

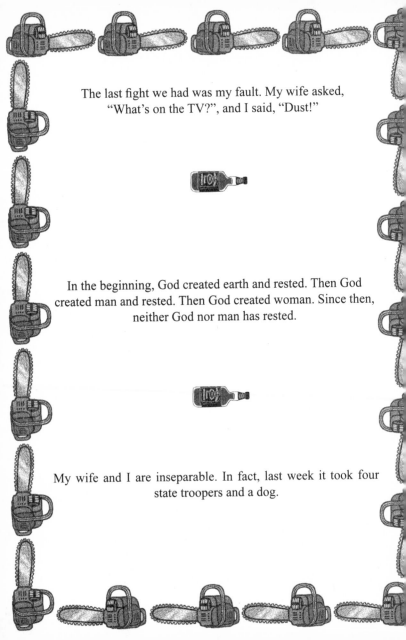

In the beginning, God created earth and rested. Then God created man and rested. Then God created woman. Since then, neither God nor man has rested.

My wife and I are inseparable. In fact, last week it took four state troopers and a dog.

What is an archeologist?
Someone whose career is in ruins.

What happens when two snails fight?
They slug it out.

What did one frog say to the other?
Time sure is fun when you're having flies.

So I said, "Do you want a game of darts?" and he said, "OK then", so I said, "Nearest to bull starts", so he said, "Baa" and I said "Moo", then he said "you're closest".

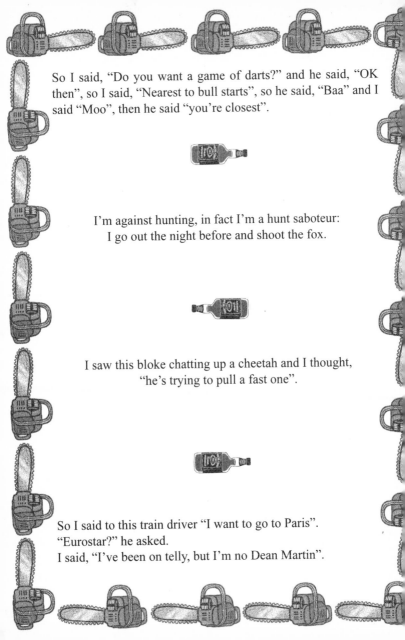

I'm against hunting, in fact I'm a hunt saboteur:
I go out the night before and shoot the fox.

I saw this bloke chatting up a cheetah and I thought,
"he's trying to pull a fast one".

So I said to this train driver "I want to go to Paris".
"Eurostar?" he asked.
I said, "I've been on telly, but I'm no Dean Martin".

A three-legged dog walks into a saloon in the Old West. He slides up to the bar and announces: "I'm looking for the man who shot my paw".

A group of chess enthusiasts checked into a hotel and were standing in the lobby discussing their recent tournament victories. After about an hour, the manager came out of the office and asked them to disperse. "But why?" they asked, as they moved off. "Because," he said, "I can't stand chess nuts boasting in an open foyer ".

There was a man who entered a local paper's pun contest. He sent in ten different puns, in the hope that at least one of the puns would win. Unfortunately, no pun in ten did.

A Jew walks into a bar with a parrot on his shoulder. The bartender asks, "Hey! Where'd you get that?"
The parrot says, "In Brooklyn, there's thousands of them!"

MACHO WORDS
OF WISDOM

A dreamcatcher works, if your dream is to be gay.

Always end your child's name with a vowel so that when you yell it, the name will carry.

The worst time to have
a heart attack is during a
game of charades.

Every fight is a food fight
when you're a cannibal.

How to store your baby walker: First, remove baby.

Saw it, wanted it, threw a fit, Got It!!

My mind works like light-
ning. One brilliant flash
and it's gone.

Friends help you move.
Real friends help you
move the body.

People think it must be fun to be a super genius, but they don't realize how hard it is to put up with all the idiots in the world.

Cheese: milk's leap toward immortality.

A day without sunshine
is like, night.

Adults are just kids
with money.

You're not drunk if you can lie on the floor without holding on.

I'm in no condition to drive. Wait! I shouldn't listen to myself, I'm drunk!

When I die, I want to go peacefully like my grand-father did, in his sleep –not screaming, like the passengers in his car.

If you love your job, you haven't worked a day in your life.

Two things are infinite: the universe and human stupidity; and I'm not that sure about the universe.

Marriages are made in heaven. But then again, so are thunder and lightning.

Half of the people in the world are below average.

Health is merely the slowest possible rate at which one can die.

All I want is less to do, more time to do it, and higher pay for not getting it done.

What do you call people who are afraid of Santa Claus? Claustrophobic.

Honolulu–
it's got everything. Sand
for the children, sun for
the wife, sharks for the
wife's mother.

42.7% of all statistics are
made up on the spot.

A clear conscience is
usually the sign of
a bad memory.

Life's tough,
get a helmet!

Never drive through a
small Southern town at
100mph with the local
sheriff's drunken 16-
year-old daughter
on your lap.

All my drinking buddies have a racing problem.

It is not MY fault that I never learned to accept responsibility!

Programming today is a race between software engineers striving to build bigger and better idiot-proof programs, and the universe trying to produce bigger and better idiots. So far, the universe is winning.

Marriage is a three-ring circus: engagement ring, wedding ring, and suffering.

In weight lifting, I don't think sudden, uncontrolled urination should automatically disqualify you.

The trouble with being punctual is that nobody's there to appreciate it.

All my life, I always wanted to be somebody. Now I see that I should have been more specific.

Advice is what we ask for when we already know the answer but wish we didn't.

Man invented language to satisfy his deep need to complain.

There are three kinds of people: those who can count and those who can't.

Do you know why they call it "PMS"? Because "Mad Cow Disease" was already taken.

Just because nobody complains, doesn't mean all parachutes are perfect.

Never be afraid to try something new. Remember, amateurs built the ark. Professionals built the Titanic.

Never kick a fresh turd
on a hot day.

In primitive society,
when native tribes beat the
ground with clubs and
yelled, it was called
witchcraft; today, in
civilized society,
it is called golf.

An optimist will tell you
the glass is half-full;
the pessimist, half-empty;
and the engineer will tell
you the glass is twice the
size it needs to be.

The most dangerous
position in which to sleep
is with your feet on your
office desk.

Only two things are necessary to keep one's wife happy. One is to let her think she is having her own way, and the other is to let her have it.

You tried and you failed, so the lesson is: never try.

Only a fool argues with a skunk, a mule or the cook.

Vampires are make-believe, like elves, gremlins, and Eskimos.

Hippies, hippies... they want to save the world but all they do is smoke pot and play Frisbee.

Always remember you're unique, just like everyone else.

Duct tape is like The Force. It has a light side, a dark side, and it holds the universe together.

Always forgive your enemies; nothing else annoys them so much.

Stupidity got us into this mess, why can't it get us out?

Swearing was invented as a compromise between running away and fighting.

143

Money won't buy happiness, but it will pay the salaries of a large research staff to study the problem.

Constipated people don't give a crap.

Before you criticize someone, you should walk a mile in their shoes.

That way when you criticize them, you are a mile away and you have their shoes.

Anyone can give up smoking, but it takes a real man to face cancer.

www.nicotext.com

www.nicotext.com